Tugs in Colour
- Northern Europe

by

Bernard McCall

INTRODUCTION

Northern Europe is a huge geographical area and the ports covered in this book are but a glimpse of the huge variety where tugs can be seen. The choice of locations must inevitably be a personal one but it is not random. Rather the locations have been selected to illustrate the wide variety of tugs that have been seen in northern Europe over the last forty years. Whilst not ignoring the current scene, I have deliberately selected many images taken in the latter part of the 20th century and there are two reasons for this. Firstly, it gives an opportunity to illustrate tugs of varying designs before towage began to be dominated by standard designs from Dutch and Spanish shipbuilders. Secondly, it offers the reader images of some tugs that may be unfamiliar. The rapid growth of digital photography and shipping websites each provide a ready source of ship photographs, sadly many of dubious quality. I hope that this book offers a wide range of images of which many will be new to most readers.

I have also endeavoured to provide a variety of scenes with some tugs at work, others at sea, and others again at quaysides so that port installations and settings can be seen. Modellers will hopefully appreciate the attempt to offer more than a standard three-quarter bow view in the selection.

Knowing that many readers are interested in the propulsion machinery and power of tugs, outline details of these, where known, are generally provided in the captions but such figures should be considered to be a guide rather than definitive

statement. Engine and equipment modifications can affect bollard pull, a owners are not averse to being overly optimistic when quoting details of this figu

The photographs are arranged in a general geographical sequence from Rus to Germany although I have allowed myself some occasional deviations wher considered this to be appropriate. Some of the places mentioned will be unfami to many readers and so a good atlas is recommended. Attempting to give details of port locations would have led to confusion and overly long captions.

Acknowledgements

As always, I must acknowledge the help of those who have loaned their preci colour slides and provided images in other media. The range of vessels a locations featured in the book would have been very much narrower without willing assistance of those photographers. Their contributions are acknowledg individually beneath the relevant photograph. I must also thank my friends Scandinavia who have done their utmost to research the history of several tu and have provided several photographs. Once again, my good friend Gil May has checked several drafts of the book and made many corrections and w alterations as have my sons, Iain and Dominic. I must also record my gratitude the staff at the Amadeus Press for their contribution to the finished product.

Bernard McCall Portishead August 2010

Published by Bernard McCall, 400 Nore Road, Portishead, Bristol, BS20 8EZ, England. Website : www.coastalshipping.co.uk. Telephone/fax : 01275 846178. E-mail : bernard@coastalshipping.co.uk. All distribution enquiries should be addressed to the publisher.

Printed by Amadeus Press, Ezra House, West 26 Business Park, Cleckheaton, West Yorkshire, BD19 4TQ. Telephone : 01274 863210; fax : 01274 863211. E-mail : info@amadeuspress.co.uk; website : www.amadeuspress.co.uk

ISBN : 978-1-902953-50-2

Front cover : During the 1970s, the Max Sieghold shipyard in Bremerhaven built a series of thirteen tugs for Bugsier Reederei und Bergungs, all driven by twin Schottel rudder propellers in Kort nozzles. These were very successful and served the company well for over two decades. The **Bugsier 9** (DEU, 180gt/78), photographed in the River Elbe on 26 August 2000, was launched on 15 April 1978 although some sources quote 5 April as the launch date. She was handed over on 22 May. Like all other tugs in the series, power comes from two 4-stroke 6-cylinder Deutz engines each of 870bhp. She has a bollard pull of 30 tonnes. Another tug in the series but with a significant difference is illustrated on page 67. In 2001, the **Bugsier 9** was sold to Spanish operators to work in the narrow confines of the Basque port of Pasajes and she was renamed **Facal Diecinueve**.

(Bernard McCall)

Back cover : The name of this tug seems to have been something of a problem. was launched at the Selby shipyard of Cochrane & Sons Ltd as **Axel** on 21 June 1 and delivered on 26 September. Of 218gt, she is powered by a 4-stroke 9-cylin Ruston & Hornsby engine of 2460 bhp which drives a controllable pitch propeller gives her a bollard pull of 25 tonnes. According to *Lloyd's Register*, it was in 1991 she was renamed **Axel av Halmstad**, but Swedish sources suggest that this chang name occurred in 1989. All agree that she became **Axel af Göteborg** in 19 Although her name links her with two other Swedish ports, she was approach Stockholm when photographed on 27 August 2000. Later in the year, she left the R Bolaget fleet but remained in Sweden for she was acquired by Rundviks Rederi AE whom she was renamed **Axel af Rundvik**.

(Bernard McC

2

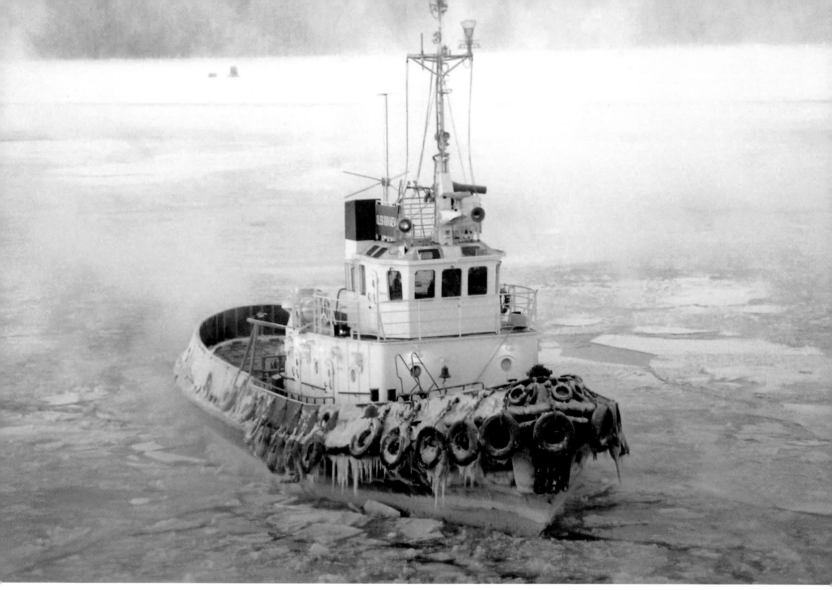

We begin our survey in Russia with this atmospheric view of the *Oleg Kuvayev* (RUS, 182gt/95) at Vysotsk on a bitterly cold 27 December 2001. She is named after a Russian artist, designer and animator born in 1967. She was built at the Gorokhovets shipyard and is powered by two 4-stroke 8-cylinder Pervomaysk engines, each of 802bhp, driving two controllable pitch propellers. This shipyard concentrated on building tugs from 1972 and this vessel seems to have been the final one of a standard design that had changed little over the years.

(Barry Standerline)

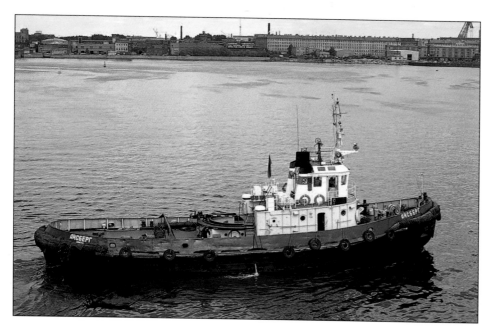

Thanks to the number of cruise vessels visiting St Petersburg in recent years, the number of tug photographs from that port has increased considerably. Photographs of them in Communist days, however, are much rarer. On 15 June 1978 we see the *Aysberg* (RUS, 225gt/69) with hammer and sickle on her funnel. She was built locally at the Petrozavodsk shipyard in St Petersburg, then called Leningrad. She has two 2-stroke 6-cylinder Russkiy engines, each of 600bhp, driving two controllable pitch propellers without a gearbox. Since the late 1950s, this yard concentrated on the construction of tugs, mostly of standard designs. A huge number of tugs of this design were built at two Russian shipyards between 1963 and 1984. The design was designated Project 498 and given the mercantile code BK-1201. It is believed that the *Aysberg* (also written *Aisberg*) was originally named **BK-1242**.

(John Wiltshire)

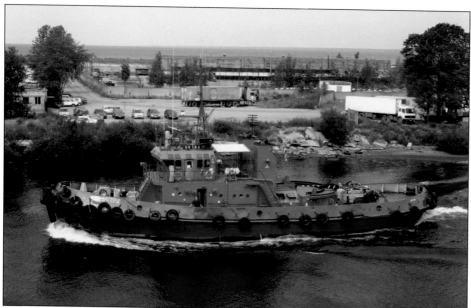

In the two decades since the end of the Communist regime in Russia, private enterprise companies have been established in the port of St Petersburg with varying degrees of success. In 2010, the Baltic Fleet Co Ltd (Baltiyskiy Flot) had a fleet of eight vessels comprising seven tugs and one pollution control vessel. All the vessels had been owned by Amberholding Latvija and worked in Riga. PKL Ltd took over this company in 2003 (see page 6) and transferred its tugs to work with those of Baltic Fleet in St Petersburg. The tugs now seem to have various liveries, at least two wearing the unattractive royal blue and scarlet of the *Vetra* (RUS, 333gt/00). Her design seems to date back to that of the large tugs and supply ships built for Russian ownership in the 1980s and bears little resemblance to western European tugs being built at the turn of the century. She was constructed at the Severnav shipyard in Turnu Severin, Romania, a yard better known for general cargo ships and supply vessels. Her two 4-stroke 6-cylinder MAN engines, each of 1200bhp, drive two controllable pitch propellers. She was photographed on 4 July 2008 in St Petersburg's Morskoy Canal, the main waterway connecting the sea at the eastern end of the Gulf of Finland to the port and Neva River.

(Simon Smith)

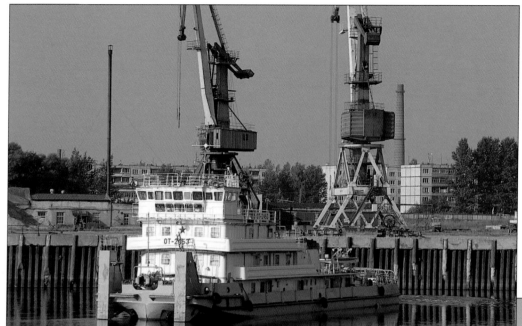

We take the opportunity to look at two tugs to be found on the Russian waterway system. There are huge numbers of tugs of varying designs and pusher tugs have come to dominate during the last thirty years. In the Communist years, designs of new Russian ships were allocated Project numbers and that system has persisted into the 21st century. The **OT-2453** comes from Project H-3291 and was built in 1989. The initials OT stand for "ozernyy tolkach" which is translated as "lake pusher" and the serial number gives an indication of the horsepower. The tugs were an updated and more powerful version of a design dating back to 1971. Over 60 examples of Project H-3290 and H-3291 tugs were built, the latter series having a modified wheelhouse which gives better vision. All were built at the Ganz Danubius shipyard in Budapest. The photograph was taken on 18 August 2001 as she moved away from the quay at Rybinsk, a city on the Volga River.

(Dominic McCall)

The **Volgar-13** is one of some 80 pusher tugs designated as project R-45 or R-45B that were intended originally to push barges of up to 5000 tonnes on the rivers of central and eastern Russia. They were built in three different shipyards, with construction starting in 1971 and continuing to 1984. The **Volgar-13** was built in 1976 and is one of 39 examples built at the Butyakov shipyard in Zvenigovo, a small town on the Volga river. The photograph was taken on the Moscow canal on 20 August 2001.

(Bernard McCall)

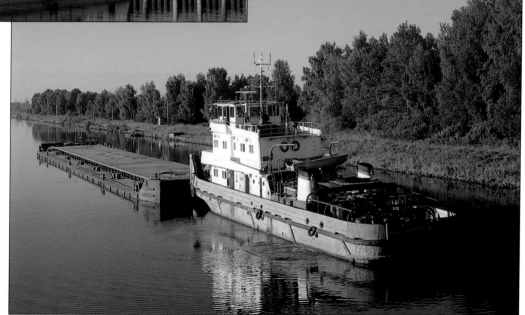

Before heading north through the Gulf of Bothnia, we take a brief look at some tugs in the Baltic states of Estonia, Latvia and Lithuania. The **Saturn** (EST, 144gt/04) is one of two sister vessels in the fleet of rapidly-growing PKL Ltd which was established in Tallinn in 1992 when it took over the tug fleet of the port of Tallinn. A modernisation and renewal programme started in 1999. The **Saturn** was built by Stocnia Polnocna (Northern Shipyard) at Gdansk and is notable because of her relatively short length, being only 19,10 metres overall. Nevertheless her two 4-stroke 12-cylinder Caterpillar engines, each of 1428bhp and driving two Z propellers, give her an impressive bollard pull of 35 tonnes. She was photographed assisting the tanker **Fortuna** (FIN, 15980gt/04) at Paldiski on 22 July 2010. Paldiski, 28 miles (45km) west of Tallinn, comprises two port areas. The Southern Port is one of five harbours operated by the Port of Tallinn whilst the Northern Port is privately owned.

(Pär-Henrik Sjöström)

The big increase in cruise ships calling at the port of Tallinn, Estonia's capital city, has resulted in an increase in the number and size of tugs based at the port. The **Jupiter** (EST, 355gt/03), noted at Tallinn on 17 May 2010, is an example of one of the newer tugs. She is a product of the DAHK Chernomorskyi Sudnobudvnyi Zavod shipyard In the Ukrainian port of Nikolaev. Built as **Jupiter**, she was renamed **Jupiters** shortly after entry into service and reverted to her original name in July 2008 after switching from the Latvian flag to that of Estonia. Power comes from two 4-stroke 12-cylinder Caterpillar engines with a total output of 2720bhp and driving two fixed pitch propellers. She has a bollard pull of 35 tonnes and is also owned by PKL. In 2003, PKL took over the ten tugs of Amberholding Latvija, as we have already noted, and moved them to St Petersburg to work with the six tugs of Baltic Fleet Co Ltd. In late 2008, it started to provide towage services in three Finnish ports using tugs from Tallinn.

(John Southwood)

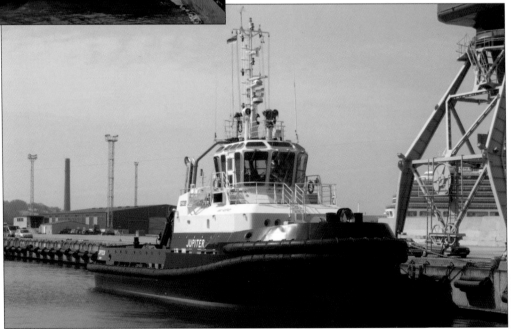

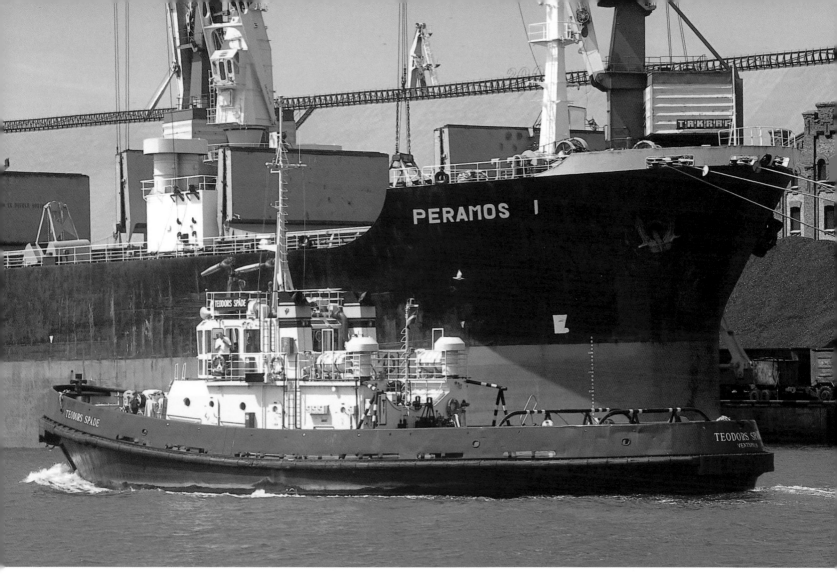

Although the capital city of Riga is a popular destination in Latvia and offers excellent opportunities for viewing ships, the port of Ventspils is possibly even better, thanks to a long promenade opposite the main berths and frequent boat tours around the harbour. Established in September 1996, Ostas Flote Ltd was the oldest private towage company in Latvia and in 2009 merged with PKL Ltd, an Estonian company which has expanded throughout the Baltic as already noted.

The **Teodors Spade** (LVA, 270gt/88) was built by Brodogradiliste "Tito" in Belgrade and is one of two identical tugs in the varied fleet of Ostas Flote at Ventspils. She is powered by two 4-stroke 6-cylinder Sulzer engines each of 1260bhp driving a controllable pitch propeller. She was named **Burun** and in Russian ownership until 1996. She has a 33 tonne bollard pull. We see her at Ventspils on 10 July 2007.

(Bernard McCall)

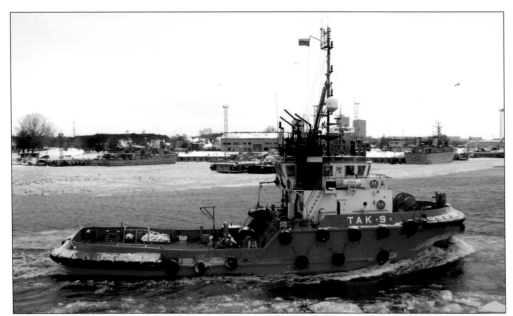

In the late 1990s and with the shackles of communism now long gone, trade through the three Baltic states was growing rapidly. Port infrastructure was being modernised and tugs were urgently needed to handle the increasing number of ships using ports in these countries. In Lithuania, Towage & Marine Assistance was established at Klaipeda and managed four tugs taken from two fleets based in Hamburg (see page 71). In 2004, it acquired its own tug, the *Tak-9* (LTU, 408gt/94), seen at Klaipeda on a wintry 17 January 2010. This tug was built by President Marine Pte Ltd in Singapore. Not now noted in *Lloyd's Register*, although it was in the late 1990s, some sources suggest she was initially named *PM 173* but there is no evidence that she traded as such and by the end of 1995 she was named *Boa Tor* for Bergen-based Taubåtkompaniet. Between 1998 and 2000, she was renamed *Birk* before reverting to *Boa Tor*. Most sources suggest that she was owned by Taubåtkompaniet but she seems to have been bareboat chartered to them. She became *Tak-9* following purchase by Towage & Marine Assistance in 2004. In May 2009, this company became Towmar Smit Baltic following a merger with Smit International. The *Tak-9* is driven by two 4-stroke 6-cylinder Nohab engines each of 1970bhp and geared to two Schottel rudder propellers. She has a bollard pull of 51 tonnes.

(Joachim Sjöström)

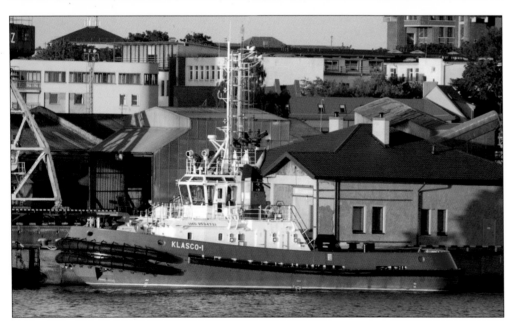

Although the production of standard tug designs from yards in Spain and the Netherlands is well reported, similar designs from elsewhere tend to be somewhat neglected. A Russian yard which has specialised in tug construction and now produces several standard designs is the Pella shipyard situated on the left bank of the Neva River 25 miles (40km) east of St Petersburg. The yard was founded in 1950 and privatised in 1992. The *Klasco-1* (LTU, 277gt/08) is an example of the yard's standard 16609 design. She was launched in August 2008 and was delivered to Klaipeda Stevedoring Ltd after successful trials in late September of that year. Her two Caterpillar 3516 engines have a total power of 4516bhp and provide a bollard pull of 55 tonnes. She was photographed at Klaipeda on the evening of 19 June 2010. Sistership *Klasco-2* was delivered one year later.

(Joachim Sjöström)

We leave the Baltic States and head north to Finland. The *Hirn* (FIN, 149gt/58) was photographed at Valkö on 30 August 2000. This small port is also known as Valkom, this being the Swedish version of the name. To confuse the issue still further, the port is often identified as Loviisa. Located on the south coast of Finland, Valkö comprises only two quays but ships up to about 30,000 grt can be accommodated so tugs are needed for shiphandling in addition to ice-breaking in winter. The *Hirn* was built at the Lödöse shipyard on the eastern bank of the Göta Älv, north of Gothenburg. On 18 March 1958 she was delivered to Stockholms Skeppsstuveri AB but without a name, the name *Bull* being given soon after delivery. In 1967 she was sold to A/S Christiania Portland Cement and was renamed *Cement 9*. A decade later she moved to Finland when bought by Reino Henriksson, of Loviisa, by whom she was renamed *Henric*. She was bought by HH Hinaus Oy, also of Loviisa, on 22 August 1994 and was then renamed *Hirn*. Her 2-stroke 6-cylinder Polar engine of 1260hp drives a controllable pitch propeller.

(Bernard McCall)

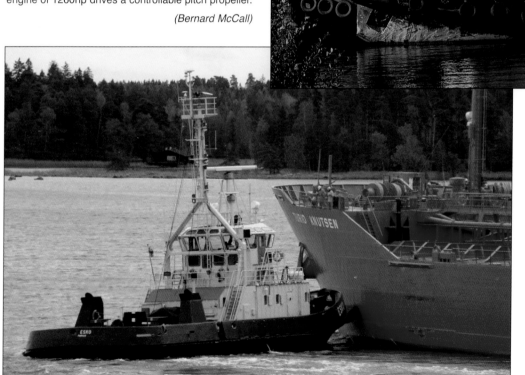

As noted on page 13, there are two oil refineries in Finland, the larger one being built by the Finnish state oil company Neste Oy at Sköldvik, 15 miles (24km) west of Porvoo on the south coast of the country, and opened in 1965. A substantial plastics and petrochemical industry soon flourished in the area. The *Esko* (FIN, 203gt/81) was the last of three identical tugs built by Hollming Oy at Rauma. She was launched on 22 May 1981 and handed over on 9 November. She is powered by two 4-stroke 8-cylinder Wärtsilä engines each of 1720bhp. Her two sister vessels were converted to pusher tugs in 1989/90. We see the *Esko* assisting the tanker *Turid Knutsen* (NIS, 15687gt/93) on 10 September 2008.

(Risto Brzoza)

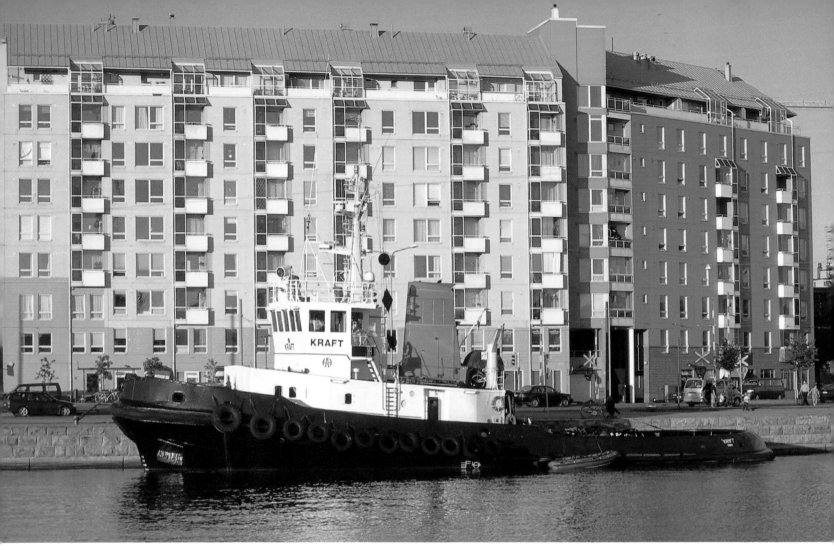

Until recently there were three separate port areas in Helsinki, all near to the city centre. With both the port eager to expand and the city to develop, a new port area was opened in November 2008 several miles east of the city. Very much in the city, however, on the evening of 14 August 1998 was the **Kraft** (FIN, 325gt/76), ex **Kone**-79. She is part of the fleet owned by Alfons Håkans, the operator of Finland's largest fleet of tugs. In 1971, the Håkans company acquired its second tug, **Simson**, which sadly sank after seven years service. With the insurance money, the company paid the deposit on the **Kraft** which had been built by Herfjord Slip & Verksted at Molde, Norway. At the time, she was named **Kone** and was owned by Kone, the crane manufacturer. Kone had decided to outsource the transport of its cranes and so Stephan Håkans, Alfons' son who then ran the company, bought the tug along with an agreement to transport the cranes on barges. This brought a new line of business for the tug fleet and barge transport grew in importance. The tug is powered by a 4-stroke 16-cylinder Nohab engine of 3520bhp which drives a fixed pitch propeller, a conventional arrangement which nevertheless gives her a useful 48 tonne bollard pull. The **Kraft** remained the most powerful tug in the fleet for many years.

(Dominic McCall)

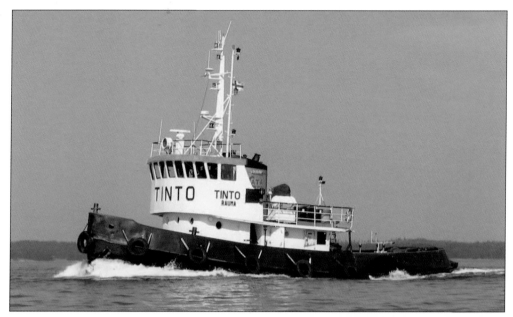

The **Tinto** (FIN, 107gt/53) has had a series of names since she was launched as **Assi** at the Groningen shipyard of J Vos & Zoon. Her original owner was Statens Skogindustrier (National Forest Industries) in the Swedish port of Piteå. She became **Royal** in 1957. Sold to Åströms Rederi in 1967, she was renamed **Storviking**. During her period in Åström ownership, her original wooden wheelhouse was replaced by a more modern one, this work being done in 1977. In 1985, she was acquired by Norwegian owners and renamed **Hinna**, becoming **Grissly** the following year, **Snik** briefly in 1990 before reverting to **Grissly**. She returned to Swedish ownership in 1996, being renamed **Stor-Joel**. Then in 2003 she was bought by Finnish owners and renamed **Tinto**. Her original 4-stroke 8-cylinder Brons engine of 500bhp was replaced in 1967 by a 4-stroke 6-cylinder Atlas engine of 960bhp and this gives her a bollard pull of 13 tonnes. We see her at Airisto, near Turku, on 4 August 2004.

(Risto Brzoza)

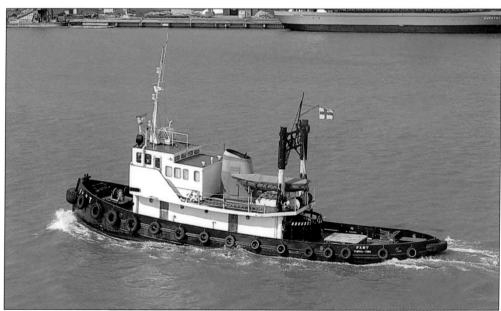

It is difficult to believe that the **Fart** (FIN, 115gt/1907) is now over a century old. Her name is the Swedish word for speed. She was built in Norway by Drammens Jernstöberi Mek. Verksted as a steam tug. Previously owned by the town of Vaasa, she had sunk at a quayside near the local power station and she was purchased and raised by the Håkans company in 1956. In 1960, she had an extensive refit during which her entire superstructure was replaced and she was converted to diesel propulsion, being fitted with four Scania engines with a total power of 720 bhp. With the **Fart** being the company's only tug and working in the small port of Vaasa, there was little room for expansion and so Alfons Håkans moved with his company to Turku (Åbo) and the tug was fully occupied with work in the port and local shipyards. In 1982 she was fitted with a B&W Alpha engine of 1260bhp which gives her a bollard pull of 13 tonnes. We see her at Turku on 10 August 1986.

(Andrew Wiltshire collection)

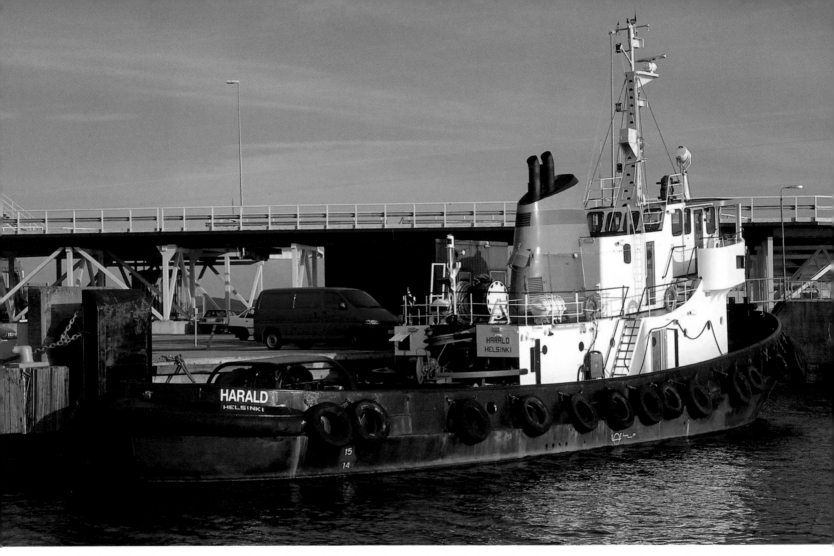

The *Harald* (FIN, 178gt/63) is seen on 29 August 2000 at Naantali, a busy port situated a few miles north of Turku and handling tankers and bulk carriers in addition to coasters and ferries. The tug was alongside the ferry terminal when photographed on 1 July 2007. She was built at the Bolsønes Verft yard in Molde, Norway, as *Kärnan* for Helsingborgs Ångslups AB, this company becoming Helsingborgs Bogserings AB in 1976. She took her present name in 1988 following sale to S & H Satamahinaus, of Helsinki, and entered the fleet of Alfons Håkans in 1991 when Håkans bought this company along with its two tugs. Her two 4-stroke 8-cylinder MAN engines, with a total of 1600bhp, are geared to a single controllable pitch propeller and give a bollard pull of 18 tonnes. Håkans vessels are identifiable by the funnel livery of scarlet with blue band and blue top. These colours came about after the Scania engines had been fitted in the *Fart* and Alfons Håkans agreed to paint the funnel the same colour as was used on Scania Vabis vehicles. Alfons added the blue for a more maritime effect.

(Dominic McCall)

Photographed at Naantali on 15 May 2006, the **Ajax** (FIN, 288gt/63) was built for the Swedish navy by Åsiverken at Åmål and completed in October 1963 as **HMS Ajax**, pennant number A252. Tugs built at the Åsiverken yard will feature prominently in this book. She was equipped for a crew of 20 whilst in naval service. She was renamed **Tuggard** in 1995 but reverted to **Ajax** in 2000. She is powered by a single 2-stroke 6-cylinder Polar diesel engine of 1650bhp driving a controllable pitch propeller and has a bollard pull of 20 tonnes. Since 2000 she has been owned by Idäntie Ky - Österled KB, of Turku, a company specialising in the transport of heavy lifts and timber by barge.

(Risto Brzoza)

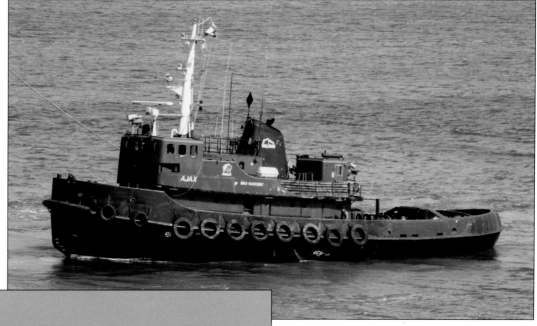

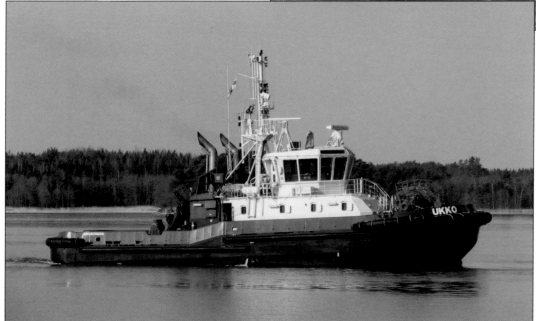

The **Ukko** (FIN, 583gt/02) is typical of the powerful tugs now being built in Spanish shipyards, in this case Astilleros Armon at Navia from where she was launched on 15 October 2001 with delivery being made on 10 July 2002. Her bollard pull of 70 tonnes is achieved by two 4-stroke 6-cylinder Wärtsilä engines with a total output of 6700 bhp geared to two directional propellers. Along with sister tug **Ahti**, she was built for service at one of the two oil refineries in Finland operated by Fortum Oil & Gas Oy which had been formed out of a merger with Neste Oy in 1997. Fortum shed its oil activities in 2005 and these were taken over by Neste Oil, the company's tankers and three tugs being operated by Neste Oil Shipping. This photograph shows the **Ahti** near the refinery at Naantali on 23 April 2005.

(Risto Brzoza)

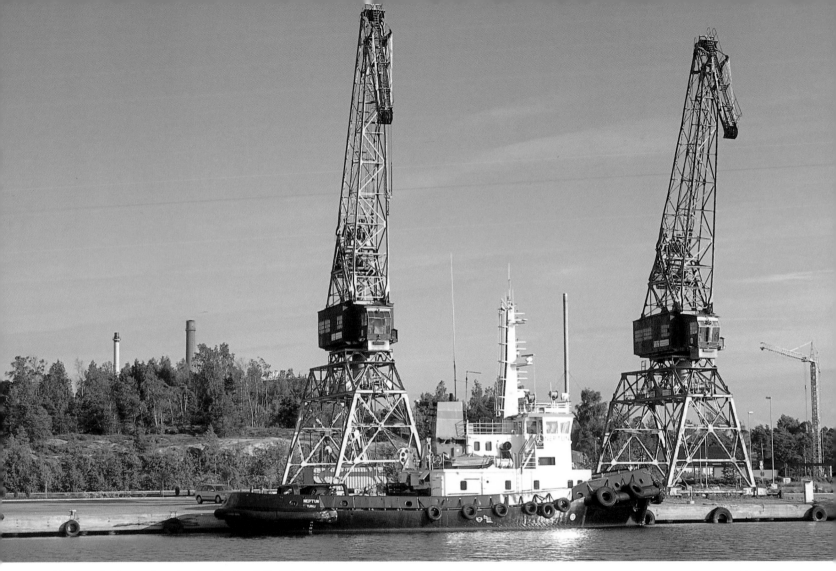

The funnel colours tell us that the **Neptun** (FIN, 324gt/80) is another Håkans tug. Photographed at Rauma on 30 June 2007, she is not too far from the yard where she was built, namely that of Hollming Oy. She was launched on 19 February 1980 and delivered as **Heimo Saarinen** to Oy Hangon Hinaus at Hangö (Hanko), becoming **Neptun** in 1989 after the owning company had been acquired by Alfons Håkans. Her 2-stroke 9-cylinder Wärtsilä engine of 3910bhp drives a fixed pitch propeller and provides a bollard pull of 37 tonnes. This angle was chosen deliberately to show the two preserved cranes on the quayside. With a safe working load of 6000 kilogrammes, they were built by Rauma-Repola Oy in 1952 and were powered by MAN machinery. Heimo Saarinen, incidentally, had been the owner of Oy Hangon Hinaus and in 1971 bought the steam tug **Santtu**, built in 1894, and presented it as a museum ship to the city of Pori in 1982.

(Bernard McCall)

Scandinavian tugs are named after characters in Greek mythology as frequently as characters from Norse myth, especially those characters exemplifying strength. The **Hercules** (FIN, 161gt/60) is just one example. Based at Vaasa where she was photographed on 30 June 2007, she is yet another tug to have been built by AB Åsiverken at Åmål. In December 1960 she was delivered as **Bill** to Stockholms Transport & Bogserings AB and was transferred to Broströms Rederi AB, of Stockholm, in 1977. She left Swedish ownership two years later when sold to Pietersaaren Hinaus Oy, of Pietarsaari (Jakobstad) in Finland and renamed **Hercules**. On 24 January 1995 she was sold to Oy Vaasan Hinaus, of Vaasa. She is powered by a 2-stroke 4-cylinder Polar engine of 1020 bhp which drives a controllable pitch propeller. It is interesting to note that, according to the 2008/9 edition of *Lloyd's Register*, tugs named **Hercules** are at work throughout the world in places as varied as New York, Santos, Guatemala, Trieste and Havana to name but a few.

(Bernard McCall)

We soon see another **Hercules**. In fact, it is the same day and the same port. This tug was formerly the **Hercules** of the Swedish Navy and had pennant number A323. Also a product of the Åsiverken yard in Åmål, she was launched on 18 December 1968 and delivered the following year. She was based at the huge underground naval base at Muskö, south of Stockholm. She left naval service in 1999 and was initially sent to the Swedish Maritime Museum in Karlskrona but was sold four years later. In 2007, she was bought by Oy Vaasan Hinaus and, after being slowly refurbished for commercial use and named **Hector**, has entered service at the port of Vaasa.

(Bernard McCall)

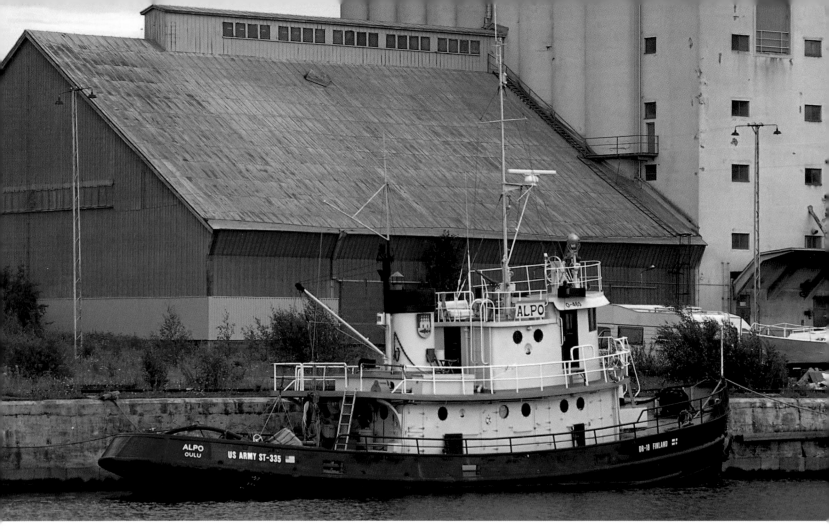

Readers will notice that several of the tugs which appear in this book are remarkable for one reason or another. The **Alpo** (FIN, 106grt/43) is certainly remarkable. She was built by the United Boat Service Corporation at City Island, New York, for the United States army and entered service as **ST-335**. After entering service, she joined a convoy heading for England and service in the D-Day landings. At the end of World War 2, she was one of 24 such tugs acquired by Finland's Ministry of Supply to be used in fulfilling the requirements of the Truce of Moscow (19 September 1944) relating to mine clearing in the Baltic Sea. She was renamed **DR-18**, the letters denoting "diesel-raivaaja" which is the Finnish equivalent of "diesel minesweeper". In 1951, she was sold for commercial service in the Finnish port of Oulu and was rebuilt at the F W Hollming shipyard in Rauma. Her foredeck was raised and an icebreaker bow fitted, making her suitable for harbour towage and icebreaking. She was renamed **Alpo**, after the city's deputy mayor. She was taken out of service in 1991. Abandoned for almost a decade, she was then taken over by a preservation group which has restored her to her former glory. Indeed in May 2004, she left Oulu for a voyage to the D-Day 60th anniversary celebrations in Caen still powered by her original Atlas Imperial diesel engine of 400bhp which gives her a bollard pull of 5.8 tonnes. This photograph was taken in Oulu's Toppila harbour on 25 July 2004 following her return from Normandy.

(Bernard McCall)

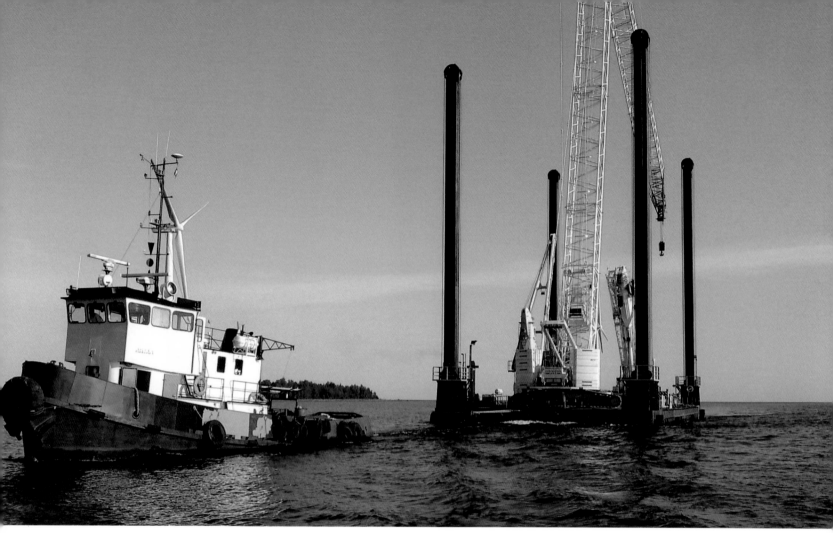

By a strange coincidence, our next tug also dates from 1943. The *Arska* (FIN, 60gt/43) was built at the Thorne shipyard of Richard Dunston Ltd. Launched on 3 September 1943, she was delivered during October to the Ministry of War Transport as *TID 41*. Along with *TID 40*, she suffered damage when the gates of the Cambrian Drydock in Swansea were carried away during a high tide on 14 April 1945. In 1946 she was sold to the Government of Finland along with seven sister tugs and all eight were towed in convoy from Swansea via Dartmouth to Finland. She was initially renamed *B7* but became *John Bull* when acquired by private owners in 1947. When these owners merged with Rauma-Repola Oy, she was renamed *Repola 4* in July 1961. Registered at Savonlinna, this was the start of her career in the Saimaa Lakes system. When built, she was powered by a compound steam engine of 220ihp built by J Dickinson & Son Ltd, Sunderland. Steam was supplied by a coal-fired boiler. In 1969 this engine was replaced by a Mercedes-Benz 424LA diesel engine of 500bhp. Laid up in 1974, we next hear about her nine years later when she was bought and renamed *Arska*. She came into the ownership of a new company in 1989, this being Itä Suomen Hinaus Oy (Eastern Finland Towing Company). Far from the Saimaa Lakes when photographed on 5 August 2009, she was bringing a barge carrying a 500-ton crane to the Ajos windfarm site off Kemi in the north of the Gulf of Bothnia.

(Henri Paavola)

17

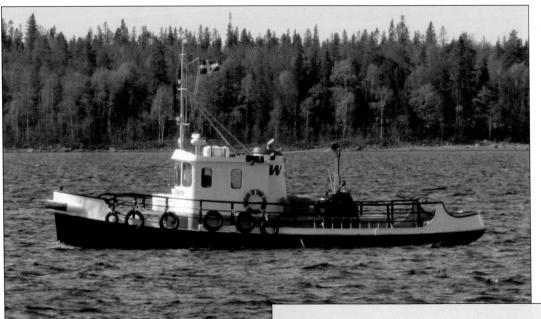

Not quite the oldest tug in this book, the *Vikingen* is believed to have been built as a steam yacht in 1883 by C O Göranssons Mekaniska Verkstad in Själevad as *Maria* for its own account. She was renamed *Ingrid* in 1910 and *Viking* following rebuilding as a tug in 1917. Originally powered by a steam engine of 20hp, this was replaced in 1934 by an Ellwe diesel engine of 50hp. Between 1936 and 1955 she was owned by Gottfrid Åström who fitted her with a steam engine once again because of oil shortages during World War 2. She returned to diesel power in 1954 with the fitting of a Scania engine of 90hp and the following year the tug was sold to paper manufacturer ASSI in Karlsborg and was renamed *Vikingen*. We see her off Karlsborg on 29 May 2009. Most of the vessels arriving at Karlsborg in summer do not require tug services but her presence was needed on this occasion because she was about to assist the *Emscarrier* (ATG, 4102gt/07) which had a faulty bow thruster.

(Jan Franzén)

In 1962 the *Vikingen* had her fifth engine, this being a 6-cylinder Scania Regent of 135hp. This gave good service for a further thirty years and in 1992, she was sold to private owner Torkil Wikström in Karlsborg who, in 1999, fitted yet another engine. Of 280bhp, the Scania DSI 11 model made her a powerful tug for her size. This photograph was taken at Karlsborg after sunset on 31 December 2009. In the winter months, she fulfils a vital role in icebreaking and towage. In the background the icebreaker *Åle* (SWE, 971gt/73) is leaving Karlsborg to carry out her main duty during the ice season which is to break ice on Lake Vänern.

(Jan Franzén)

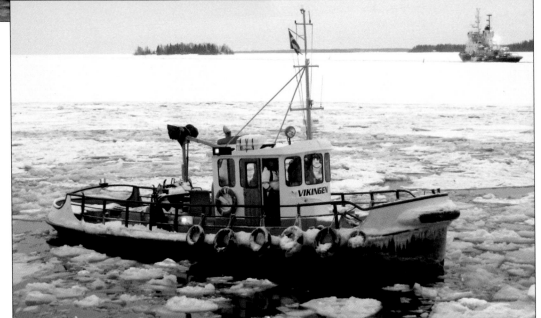

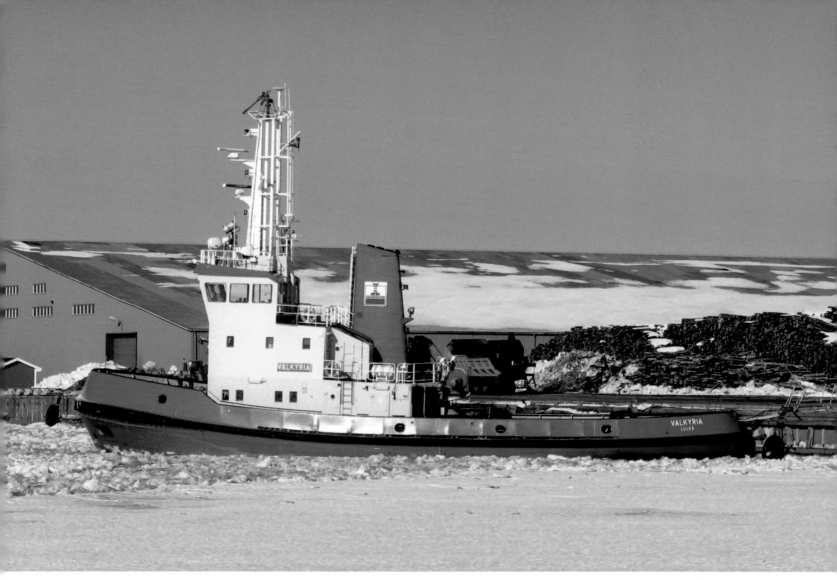

The port of Luleå in north-west Sweden was once renowned for the export of iron ore. This cargo still features prominently in exports but a wide variety of cargoes are now handled and the port uses the services of the three tugs of Luleå Bogserbåts AB. The tugs serve other ports in northern Sweden when required and the *Valkyria* (SWE, 312gt/77) is contracted out for icebreaking services in winter. Our photograph shows her about to undertake such duties at Karlsborg, 50 miles (80 km) north of Luleå, on 15 March 2008. She was built at the Åsiverken shipyard in Åmål. She has a 4-stroke 16-cylinder Nohab engine of 3520bhp driving a controllable pitch propeller, this giving a bollard pull of 35 tonnes. Her Ice Class 1A Super classification is a necessity for the work that she undertakes.

(Roland Stoltz)

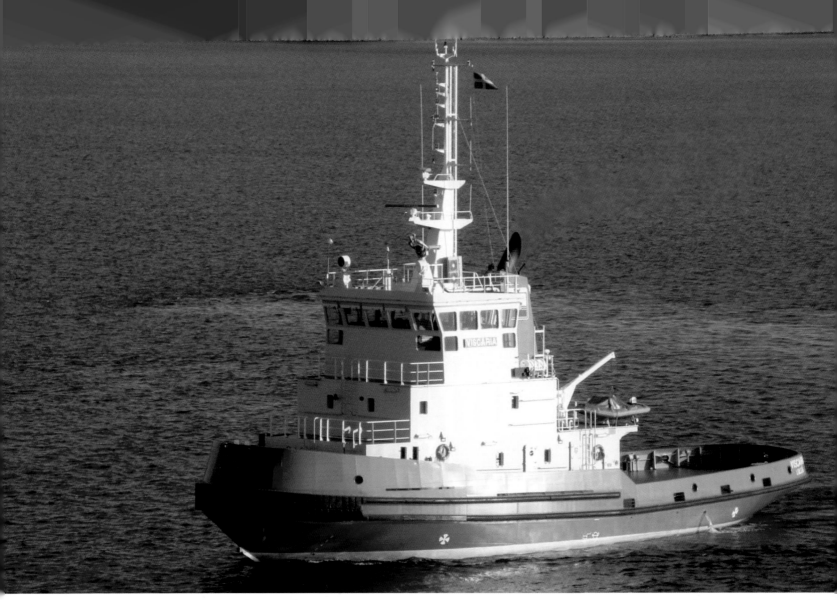

We now see a second tug in the Luleå Bogserbåts fleet, namely the **Viscaria** (SWE, 603gt/00), in much less demanding conditions at the port of Haraholmen on 8 October 2008. The newest tug in the fleet, she was built at the Kolvereid yard of Moen Slip A/S and is a rather more powerful tug than the **Valkyria**. Power comes from a 4-stroke 12-cylinder Wärtsilä engine of 5995 bhp which provides a bollard pull of 62 tonnes. Haraholmen is 35 miles (55km) south of Luleå and is the port area of Piteå.

(Nicklas Liljegren)

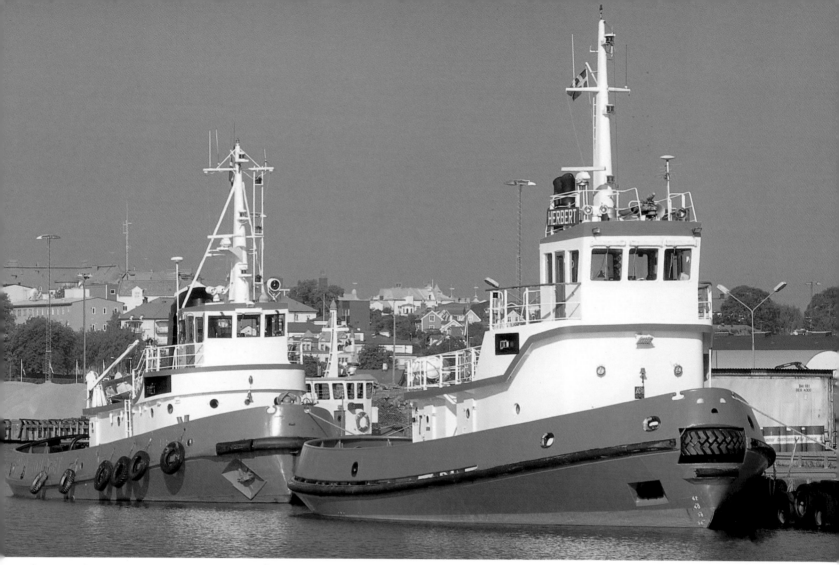

The **Herbert** (SWE, 181gt/76) is another product of the Åsiverken shipyard at Åmål. She was yard number 112 and was delivered in February 1976. Her controllable pitch propeller is driven by a 4-stroke 16-cylinder engine of 2828bhp built in England by W H Allen & Sons, of Bedford. She has a bollard pull of 28.5 tonnes. She was built as **Hans** for Göteborgs Bogsering & Bärgnings and was transferred to Broströms Rederi AB / Röda Bolaget, of Gothenburg, in 1977. During the 1980s, ownership passed through several finance companies until in late 1991 she was sold to Oskarshamns Hamn AB and renamed **Herbert**. The title of the owning company changed to Smålandshamnar AB in 1992. The slightly smaller and less powerful **Lars af Oskarshamn** (SWE, 143gt/65), ex **Hero**-99, is an earlier tug from the same builders who completed her in April 1965. Her 2-stroke 8-cylinder Alpha engine of 1050 bhp drives a controllable pitch propeller and provides a bollard pull of 15 tonnes. The tugs are seen at Oskarshamn on 29 July 2002.

(Bernard McCall)

There can be no more suitably named vessel in this book. The **Tug** (SWE, 170gt/74) was the third of four sister vessels built for Bugsier at the Max Sieghold shipyard in Bremerhaven. She was launched as **Bugsier 5** on 6 May 1974 and delivered on 8 July. She is powered by two 4-stroke 6-cylinder Deutz engines each of 870bhp and driving twin Schottel rudder propellers in Kort nozzles. Sold out of the Bugsier fleet in 1999, she was renamed **Balt-2** before becoming **Nore Commander** also in 1999 when bought by Murray's Tugs. The following year, she was sold to owners in Hull and renamed **Merchantman** but that proved to be equally short-lived for in 2001 she was sold to Stockholms Hamn AB and renamed **Tug**. In that same year she was transferred to Marin & Haverikonsult whose small fleet of tugs is kept busy in Stockholm and surrounding areas.

In this sequence of three photographs, we see her passing the lock at Södertälje on 1 September 2009. She is towing a huge tunnel section to be used on the underground suburban railway line being constructed in Stockholm, completion of which is scheduled for 2017.

(Ida Gustavsson)

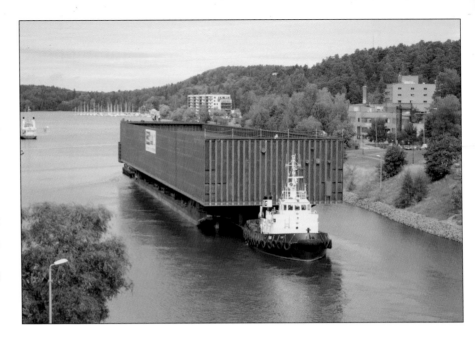

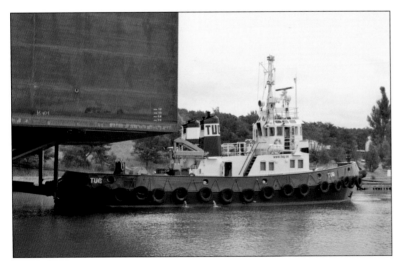

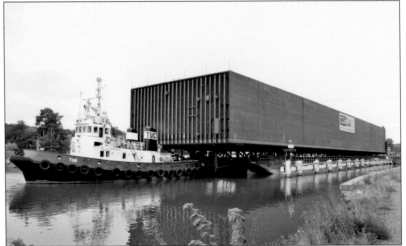

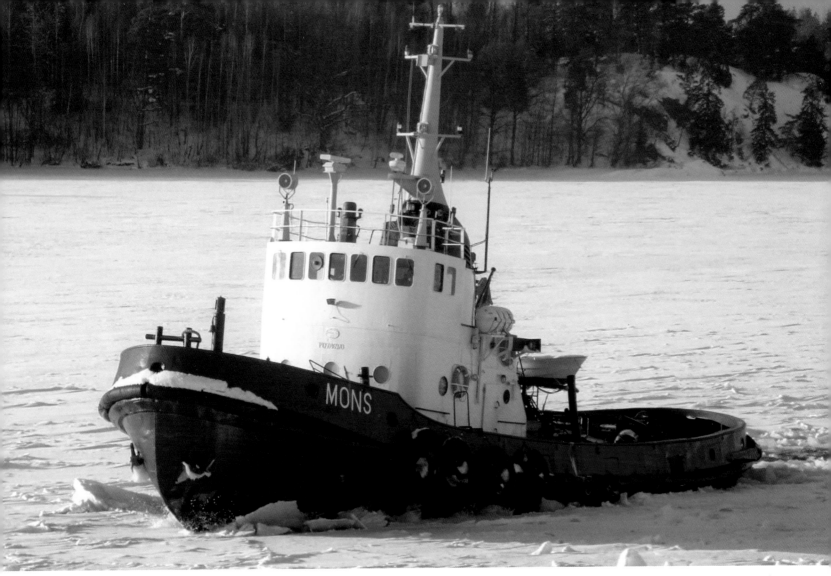

The **Mons** (SWE, 139gt/63) was built as **Bob** by Bolsönes Verft at Molde in Norway for Bugsér & Berging. In October 1985 she was sold to Fabic Scandic Leasing and renamed **Sjösport** but only two months later reverted to **Bob** when repossessed by Bugsér & Berging. Exactly one year later she was acquired by A/S Svelviksand and renamed **Mons**. A further sale saw her go back to her very first name of **Bob** in May 1996 but she had reverted to **Mons** by the end of that year when she was bought by Swedish owner Rolf Kenneth Lindberg. Power comes from a 4-stroke 8-cylinder MaK engine of 900bhp driving a controllable pitch propeller. During the winter of 2009/10, she was chartered for icebreaking duties at the expanding port of Stora Vika south of Stockholm and she was photographed in the fairway of nearby Södertälje on 25 February 2010.

(Nicklas Liljegren)

Visitors to Sweden will find a surprising number of veteran American cars lovingly preserved by enthusiasts. There are also veteran American tugs to be found in both Sweden and Finland. A good example is the *Tiger* (SWE, 154gt/44) noted in Stockholm on 29 July 2006. She was built for the US Army by the American Machinery Corporation in Beresford, Florida, as **ST-479**, the ST prefix meaning Small Tug. She was the last in a six-tug order from this company. She was in Europe for the D-Day landings and after World War 2 was sold to Dutch owners in Bergendal and was apparently working in the IJmuiden area. In February 1952,

she was acquired by the port of Karlshamn in Sweden and was renamed *Mico*. Between 1980 and 1996 she was owned privately in Stockholm, passing through the hands of four owners, one of whom gave her the name *Tiger* in 1987. Surprisingly, she returned to active towage in 1996 when bought by Gävle Bogser & Sjöentreprenader but returned to private ownership two years later when bought by a couple in Stockholm who intended to renovate her completely. She retains her original Clark 2-stroke engine of 650bhp.

(Alan Small)

The **Bonden** (SWE, 349gt/74) was the third of three tugs built by Åsiverken for AB Bohus Tug Ltd, of Uddevalla. We shall see the first two tugs on pages 30 and 31 where technical details are given. She was the first of the three to be sold, being acquired in 1978 by Stockholms Frihamns AB and renamed **Heimdal**. Ten years later, she returned to the west coast of Sweden when sold to Röda Bolaget AB, of Gothenburg, who restored her original name. Ownership passed to Svitzer Sverige AB in 1993 and she was photographed in Svitzer colours at Nynäshamn on 19 April 2010.

(Nicklas Liljegren)

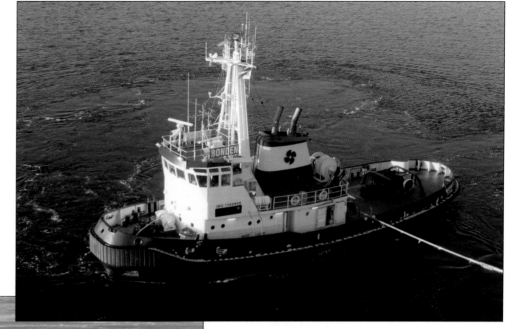

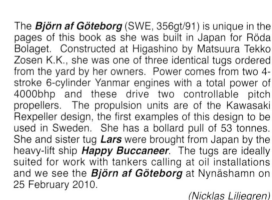

The **Björn af Göteborg** (SWE, 356gt/91) is unique in the pages of this book as she was built in Japan for Röda Bolaget. Constructed at Higashino by Matsuura Tekko Zosen K.K., she was one of three identical tugs ordered from the yard by her owners. Power comes from two 4-stroke 6-cylinder Yanmar engines with a total power of 4000bhp and these drive two controllable pitch propellers. The propulsion units are of the Kawasaki Rexpeller design, the first examples of this design to be used in Sweden. She has a bollard pull of 53 tonnes. She and sister tug **Lars** were brought from Japan by the heavy-lift ship **Happy Buccaneer**. The tugs are ideally suited for work with tankers calling at oil installations and we see the **Björn af Göteborg** at Nynäshamn on 25 February 2010.

(Nicklas Liljegren)

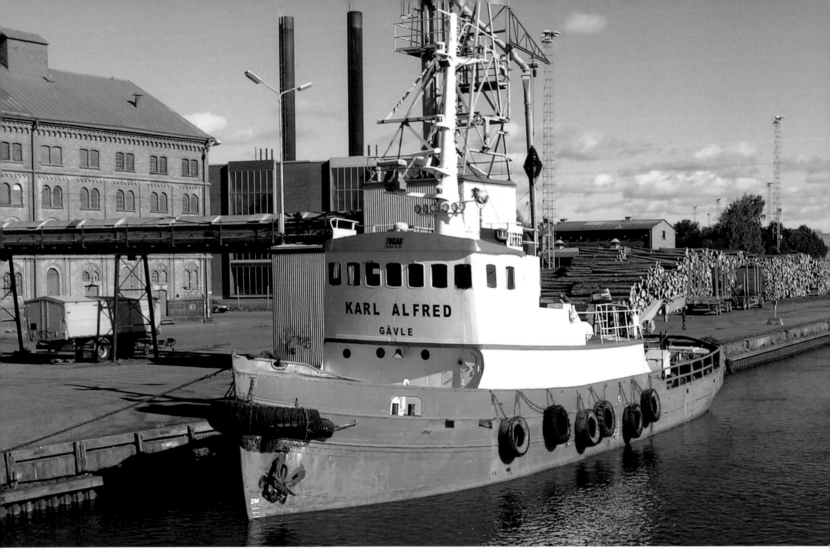

Not surprisingly in view of her age, the **Karl Alfred** (SWE, 150gt/1902) has a varied history. It is believed that she was built at the shipyard of Huiskens & van Dijk in Dordrecht as **Director Louis Gutjahr VI** for a Dutch owner. She entered Swedish ownership in 1917 and was renamed **Doggen**. Sold two years later, she was rebuilt and renamed **Ellwe**. Sold on in 1956, her then owner is thought to have fitted a new engine in 1958, presumably replacing her original 350ihp steam engine with a diesel engine. Eight years later, she was fitted with no less than four Penta diesel engines with a total output of 950bhp. In 1976, these were replaced by a Caterpillar D399 engine. The tug passed through the hands of three owners in the mid-1980s, one of whom planned to convert her to a passenger vessel but nothing came of it. She was renamed **Karl-Manfred** after a sale in 1991 and then **Karl-Alfred** in 1996. Between 1997 and 2007 she was owned by Gävle Bogsering & Sjöentreprenad AB (TUGAB) and, perhaps finally, she was bought on 20 December 2007 by Noås-Nordmuddring in Örnsköldsvik for conversion into floating offices. The photograph was taken at Norrköping on 25 September 2004.

(Lars Johnson)

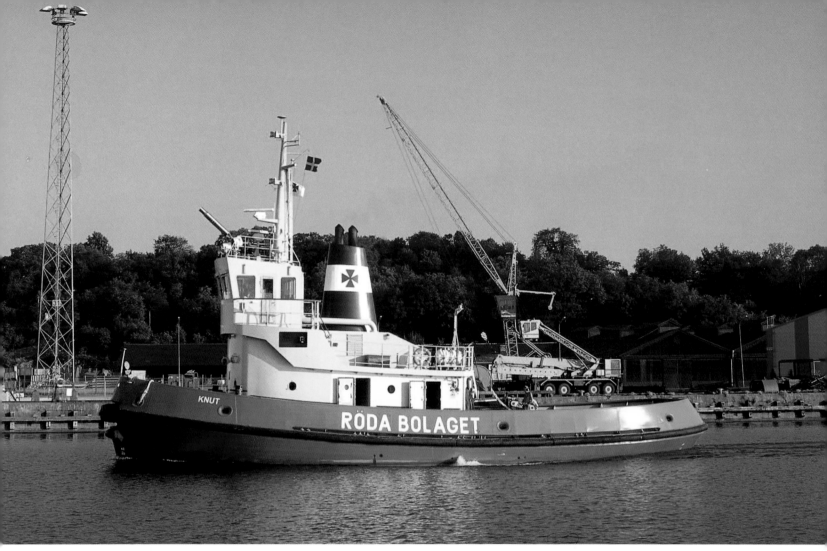

The port of Norrköping covers an extensive area and has four separate harbours. Three tugs are usually based at the port and these were in the Röda Bolaget fleet which has now become part of the huge Svitzer empire. When not working, the tugs are moored at a berth near to the town centre and can readily be seen from public areas. Having just left her berth on 29 July 2002, the *Knut* (SWE, 179gt/76) moves slowly down river. The *Knut* followed the *Herbert* from the Åsiverken yard and, with a similar Allen engine, was a sistership. She was renamed *Viscaria* in June 1993 when sold to Luleå Bogserbåts AB in Luleå but the following year was loaned to Vänerhamn AB for icebreaking on Lake Värnern. In 2000 she was bought by Vänerhamn AB and renamed *Jäveron* but almost immediately was exchanged for the *Karl* from the Röda Bolaget fleet. She was given her original name and transferred to Norrköping. By this time, Svitzer had taken over Röda Bolaget and the *Knut* was permitted to keep some vestiges of her original ownership but the familiar red band on the funnel was replaced by Svitzer's dark blue Maltese cross on a white background. On 29 July 2009, she was sold to Oy Yxpila Hinaus Bogsering Ab, in Finland, and renamed *Cetus*.

(Dominic McCall)

The **Bore af Västerås** (SWE, 155/62) is seen at Västerås, the main port on Lake Mälaren, on 11 August 1998. She was built at the Öresundsvarvet shipyard in Landskrona as **Bore**, being launched on 6 March 1962 and delivered on 27 June. Her name was amended to **Bore af Västerås** in 1980. She is powered by a 2-stroke 6-cylinder Polar engine of 1260bhp which drives a controllable pitch propeller. Of special note is that she is registered as a tug/icebreaker/ferry and as such has a certificate for 150 passengers.

(Bernard McCall)

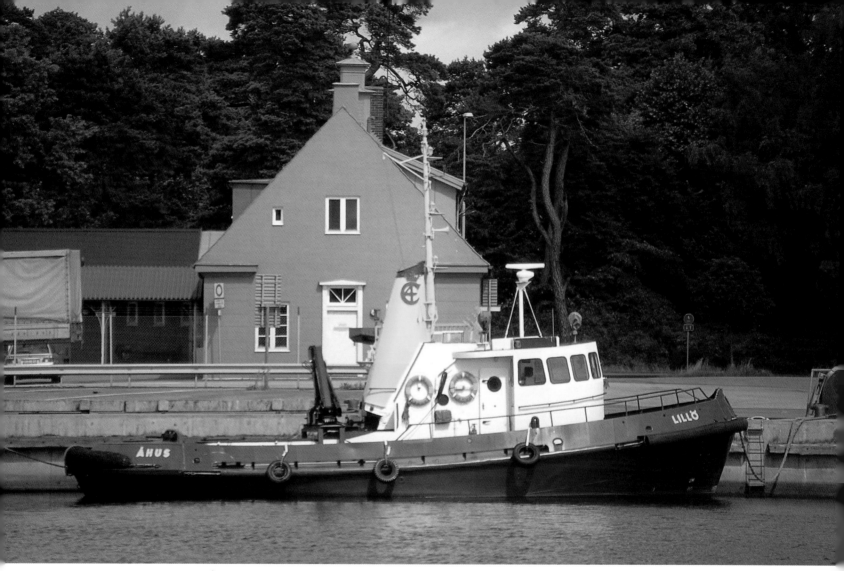

The 1968-built *Lillö* was photographed at Åhus on 24 July 2002. She was built by Wärtsilä in Helsinki as *Jelppari*, and was later renamed *Dockan*. In the winter of 1973, the forepart of her bow was experimentally covered with stainless steel cladding as part of research into the icebreaking characteristics of various vessels. It was in 1980 that she was renamed *Lillö* and became harbour tug at Åhus. In 2003, the harbour authority decided to hire in towage when it was needed and disposed of its tug to Marin- och Haverikonsult in Stockholm by whom she was renamed *Tom*. On 18 August 2006 ownership was transferred to Marin & Hamnservice KA AB. In 2004 she was extensively modified. She was fitted with a hydraulic Hiab crane but more significantly she was equipped with a much higher wheelhouse located above her original wheelhouse and her funnel was also modified. She is powered by two Scania engines with a total power output of 700bhp and geared to a Tampella controllable pitch propeller.

(Bernard McCall)

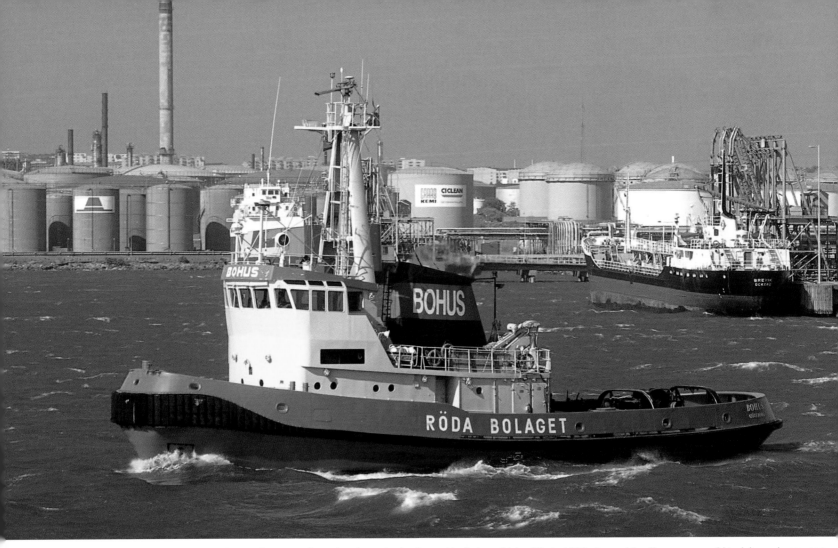

Gothenburg is a very busy port, with container vessels and tankers dominating trade and providing constant work for the local tug fleet. There is also a busy ship repair yard in the port. The tug fleet was operated by Röda Bolaget (Red Towage) which, as already noted, is now part of the Svitzer group. Photographed in the main fairway and on her way to collect an inbound container ship on 31 May 1994, the **Bohus** (SWE, 357gt/74) was another tug built by AB Åsiverken at Åmål. For her generation, she was a powerful tug with a 38 tonne bollard pull. Power was supplied by a 4-stroke 6-cylinder Pielstick engine of 3900bhp geared to a controllable pitch propeller, the engine being built locally in Gothenburg by Lindholmen Motor AB. In 1982, she and the **Dynan** were sold to Johnsonkoncernen which kept the Bohus company name and both tugs were located at the Brofjorden oil refinery. Company mergers and takeovers in the mid-1980s were complex but the company name became Röda Bolaget AB in 1987. The **Bohus** was chartered by Jebsens in 2006 for a nine month spell of service at Svea Gruva, Spitsbergen. This had only just ended when, on 16 March 2007, she suffered a total blackout whilst on passage from Wallhamn to Brofjorden and she drifted aground on rocks near Karingon. Her crew of 4 was rescued but the tug sank.

(Bernard McCall)

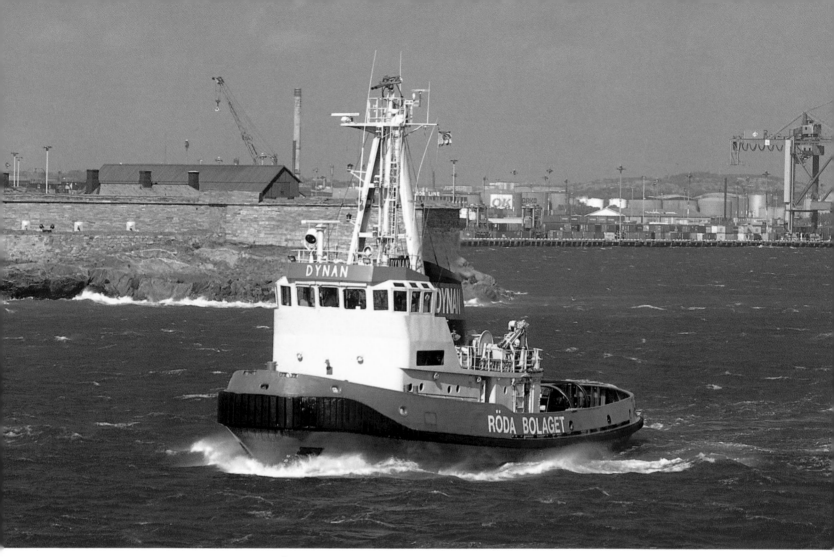

The **Dynan** (SWE, 357gt/74) passes the 17th century Älvsborg fortress at the entrance to Gothenburg harbour on 31 May 1994. Seen here in Röda Bolaget colours, the **Dynan** was the second of the three identical tugs built at the Äsiverken shipyard to work for AB Bohus Tug Ltd, of Uddevalla to which she was delivered in October 1974. The company was established in Gothenburg in 1872 by local shipping companies and traders. In 1918, a majority shareholding in the company was acquired by Dan Broström of the Broström group. Other companies including tug operators in Malmö and Stockholm were taken over but a restructuring of the Broström company in 1984 saw investment companies take over with Röda Bolaget being established in 1987. In 1999, Röda Bolaget became part of the huge A P Møller group and thus joined Svitzer within that group. From 2002, the tugs began to adopt Svitzer livery. In 2004, the **Dynan** was transferred to the parent Svitzer company in Copenhagen and was renamed **Svitzer Munin** under the flag of St Vincent & the Grenadines. She returned to Gothenburg as **Dynan** in 2007.

(Bernard McCall)

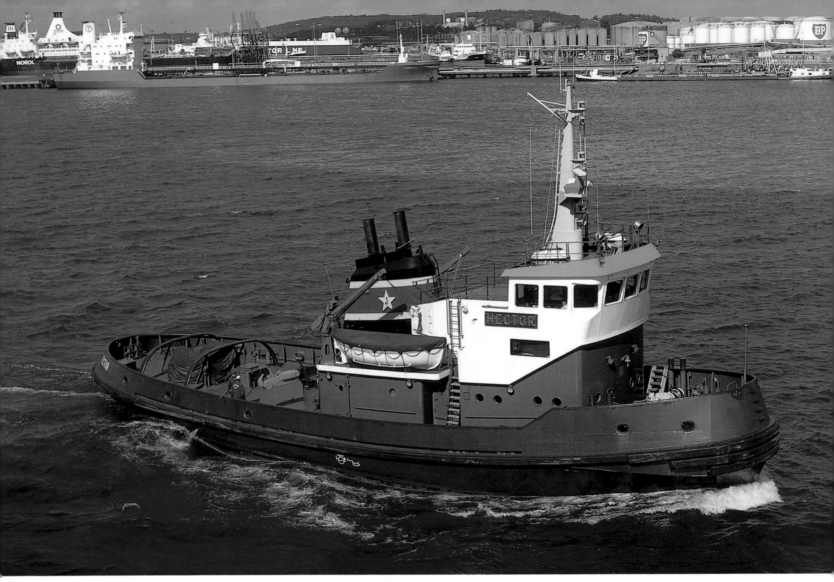

Like so many Swedish tugs, the **Hector** (SWE, 353gt/75) was built at the Åsiverken shipyard at Åmål where she was completed in April 1975. She was intended for harbour towage duties in Gothenburg and was photographed there on a sunny 22 August 1979. Sold in 1990 to owners based in Norrköping, she was converted at Landskrona the following year to an articulated pusher tug by means of an extension to her upperworks and bridge. She was renamed **Karl-Erik** and is now linked to a pontoon barge named **Oxelösund** and of some 6000 tonnes deadweight. Originally driven by a Hedemora-Pielstick engine, this was removed in 1997 and she now has two 4-stroke 16-cylinder Caterpillar engines each of 1566bhp and geared to a shaft driving a controllable pitch propeller.

(John Wiltshire)

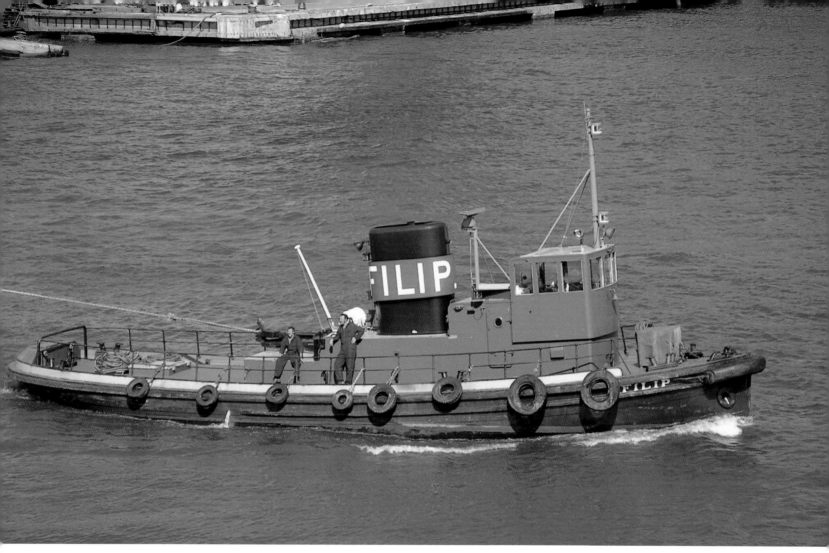

It seems remarkable that a tug built in Sweden as long ago as 1930 should be working in the UK in the 21st century. That has proved to be the fortune of the *Filip* (SWE, 72gt/30) which was photographed at Gothenburg on 22 August 1979. She was built by Lödöse Varv AB at Lödöse on the Göta Älv north of Gothenburg and delivered on 22 June 1930 to Göteborgs Bogserings & Bärgnings AB (Gothenburg Towage & Salvage Co). Her original engine was a compound steam engine of 300hp manufactured by her builder. She is understood to have been fitted with a diesel engine in 1949 and this was replaced by a 500hp diesel engine of unknown manufacture in 1958. A company merger in 1977 saw her transferred to Broströms Rederi and she remained in Gothenburg ownership when bought in 1984 by Scandinavian Towage & Salvage AB. Six years later, she was bought by Marin & Maskin, Stockholm, and was renamed *Chief*. In 1993, she left Sweden when bought by English owners Malcolm Spencer & Lesley E Campbell, of Ely. Sold to Griffin Towage in 2004, she was renamed *Chiefton* and two years later ownership passed to Baker Marine, Southampton, by whom she was renamed *Chief*.

(John Wiltshire)

33

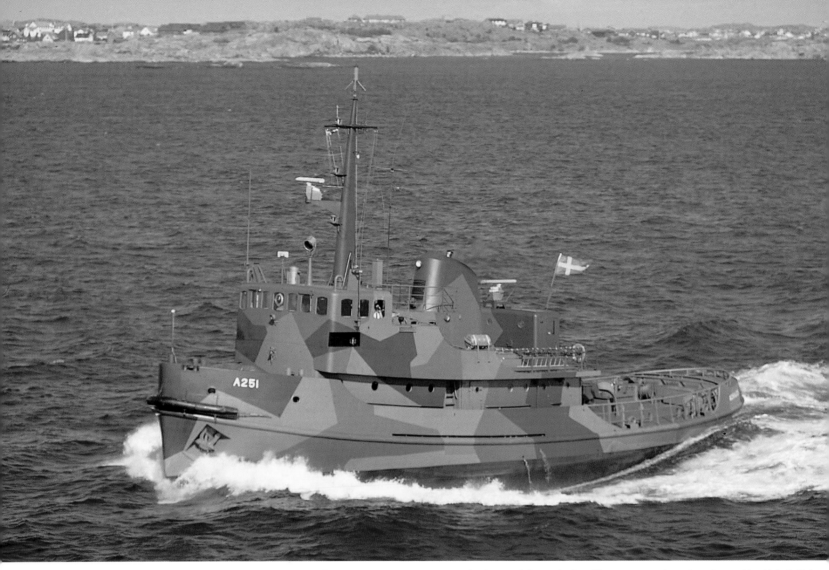

This book includes three photographs of tugs built for the Swedish navy but this is the only one of these to be in naval service when photographed. Seen at Gothenburg again on 22 August 1979 is **HMS Achilles**, pennant number A251, which was built by Åsiverken and followed **HMS Ajax** (page 13) from this yard. Launched on 30 April 1962, she had the distinction of being the longest serving vessel in the Swedish navy when sold in the Spring of 1997, her retention being the result of a need for an icebreaking tug to assist submarines. Her Nohab Polar engine is reported to give her a bollard pull of 23 tonnes. She was bought by R-Towing, a Finnish company, in 2007 and in late 2008 was sold on to Baltic Cargo Shipping, of Espoo, Finland. In 2010, she was understood to have been detained at the Finnish port of Uusikaupunki as collateral for loans by Aktiebank in Helsinki.

(John Wiltshire)

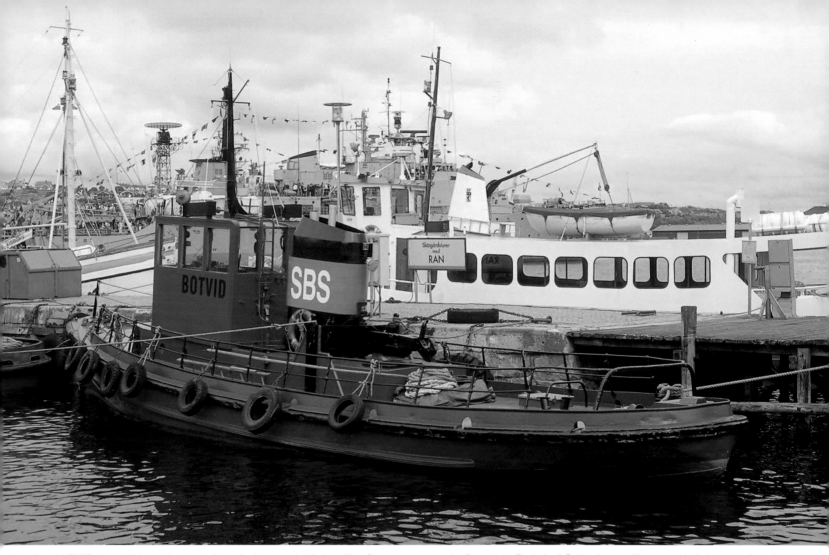

The ***Botvid*** (SWE, 30gt/16) is another tug to have had a remarkably long life. She was built by Lundby Mek. Verksted, near Gothenburg, and delivered as ***Sven*** to Göteborgs Bogserings AB (Gothenburg Towing) in August 1916. Her engine was a steam compound of 90hp. Deemed outdated in 1950, she was laid up at the Lödöse shipyard and was there fitted with a new engine the following year. This was a Bolinder-Munktell 2-cylinder diesel engine of 220bhp. She was bought by Bogserings AB Stormking in 1968 and renamed ***Storm***. In 1975 she was substantially rebuilt and fitted with a new engine, this being a Kelvin diesel of 375bhp which gave her a bollard pull of 4 tonnes. She was also acquired in the same year by Broströms Rederi, of Gothenburg, with ownership being transferred to Scandinavian Towage & Salvage in 1984. Three years later, she entered the fleet of Röda Bolaget and remained in this company's ownership until 13 November 1997 when bought by Sandinge Bogsering & Sjötransport, of Lysekil, by whom she was renamed ***Botvid***. We see her as such at Lysekil on 8 August 1998. On the first day of 1999, she was acquired by Bohus Tug but only four months later she was bought by Mikael Kland, of Särö, and was renamed ***Marcus***.

(Bernard McCall)

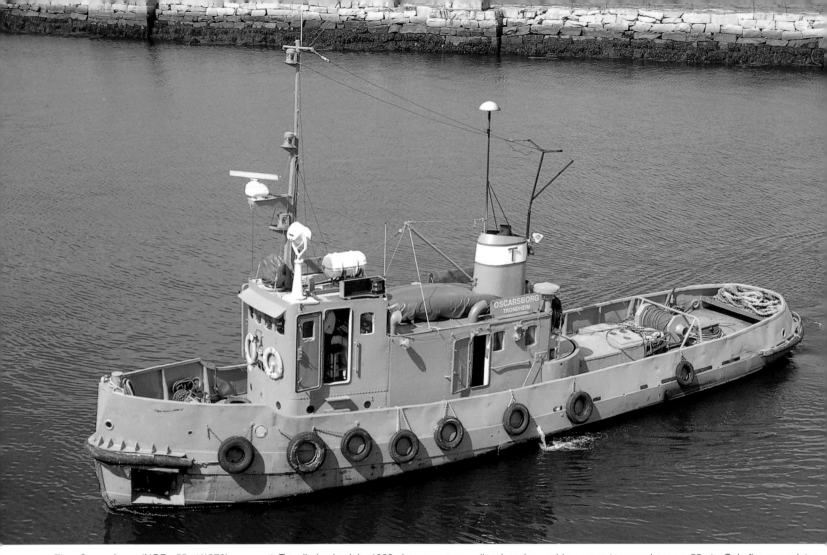

The ***Oscarsborg*** (NOR, 55grt/1876), seen at Trondheim in July 1983, has a fascinating history. She was built in 1876 by Akers Mek Verksted, Oslo, for Norway's Coastal Artillery and was named after the Oscarsborg fortress on an island in the Oslofjord. Originally she had a gross tonnage of 46grt and was powered by a compound steam engine. In 1889 she was sold to AS DS Oscarsborg, of Fredrikstad, a company which used to have a vibrant tug business towing sailing ships and barges on the lower reaches of the River Glomma. The next seventy years saw her pass through the hands of several Fredrikstad owners until in 1950 she was acquired by Fredriksstad MV and rebuilt. She was fitted with a new diesel engine and her gross tonnage became 55grt. Only five years later, she sank but was raised and refitted once again, this time being given a Crossley diesel engine of 500bhp. In 1969, she left Fredrikstad following sale to Birger Skarsvåg, of Trondheim, and the next year she was given yet another new engine, this time an Alpha diesel of 750bhp. She entered the ownership of Taubåtkompaniet in Trondheim in 1976. After a long period in lay up, she was sold in January 2006 to Olaf T Engvig, an academic involved in ship preservation.

(Jim McFaul)

Photographed as she headed north from the oil terminal at Kårsto towards her home port of Haugesund on 22 May 2006, the **Pax** (NOR, 315gt/85) is owned by Østensjø Rederi A/S, a company which specialises in owning tugs that serve oil terminals and whose vessels sport a distinctive dark blue / light blue livery. The contract to provide towage services at this Statoil terminal was the company's first such contract and had been awarded the previous year. She was built by Skaalurens Skipsbyggeri, Rosendal, and is equipped for firefighting and pollution control duties. She is powered by two 4-stroke 6-cylinder Nomo engines with a total output of 2990bhp which are geared to two directional propellers. She has a bollard pull of 40 tonnes.

(Bernard McCall)

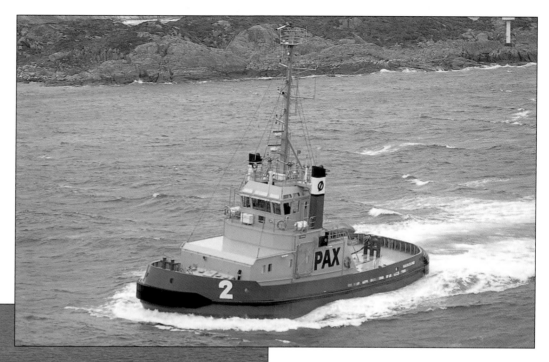

The **Haabull** (NOR, 253gt/78) is seen heading south from Bergen on 25 May 2006. She was built at the A M Liaaen shipyard, Ålesund, where she was launched on 20 October 1978 with delivery to Buksér og Bjerging in December. Her two Deutz engines with a total output of 2550bhp drive two directional propellers and provide a bollard pull of 38 tonnes. In summer 2007, she was sold to Cuxhaven-based Otto Wulf and in August was renamed **Taucher O Wulf 4**.

(Bernard McCall)

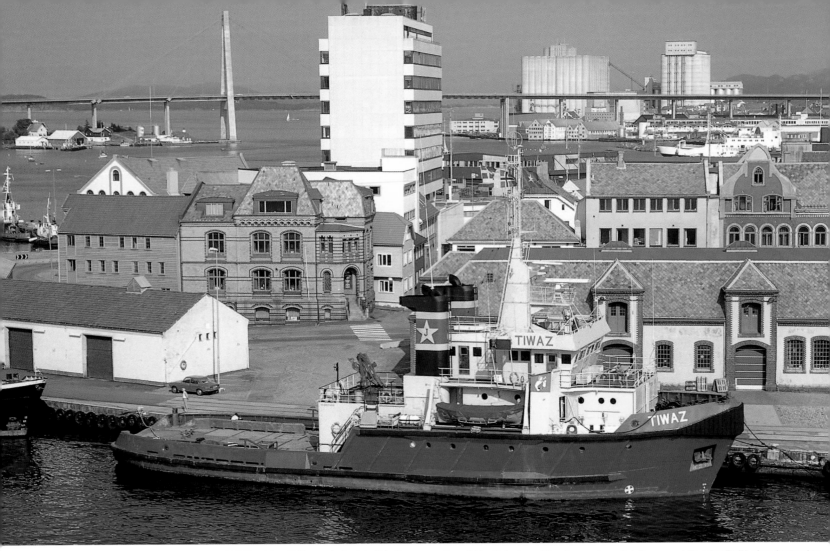

A Swedish tug in Norway. The *Tiwaz* (SWE, 499grt/78) was, in fact, built in Norway by Stord Verft for Bohus Tug, of Uddevalla, a company established in 1971 and taken over by Johnson Line in 1981. This explains the funnel colours of the *Tiwaz* when photographed at Stavanger in July 1983. She was driven by two 4-stroke 16-cylinder Polar engines which gave a total of 7040bhp and were geared to two controllable pitch propellers, this arrangement giving a bollard pull of 85 tonnes. After only eight years with her original owner, she was sold to Bahamas-flag operators not unconnected with her previous owners and she was renamed *Scan Force*. In mid-September 1989, she entered Norwegian ownership after being bought by Buksér og Bjerging and was briefly named *Tender Pull* before becoming *Bob* by the end of the year. Sold again in 1991, she was renamed *Boa Force* and came to an unfortunate end after she collided with the Saladin 3 wellhead off Thevenard Island, Western Australia, on 25 February 1994. The tug sank in 8 metres of water and was impaled on the wellhead. Salvors refloated her on 31 March but she had already been declared a constructive total loss. She was towed outside Australian territorial waters to a position about 290 nautical miles due north of Barrow Island and on 7 April was scuttled there in some 5000 metres of water.

(Jim McFaul)

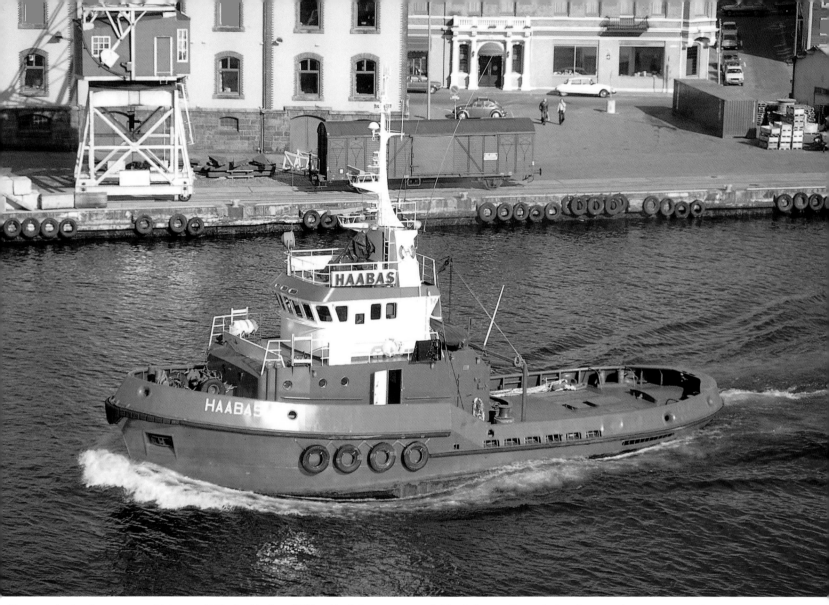

Photographed at Stavanger on 21 August 1979, the **Haabas** (NOR, 190gt/76) was built in the Netherlands by W Visser & Zoon at the "De Lastdrager" yard in Den Helder for A/S Haaland & Sonn. Her 4-stroke 12-cylinder Alco engine drives a controllable pitch propeller and gives her a total power output of 2719bhp and a bollard pull of 35 tonnes. In 2000, she was sold to other Norwegian owners and renamed **Multi Mammut**.

(John Wiltshire)

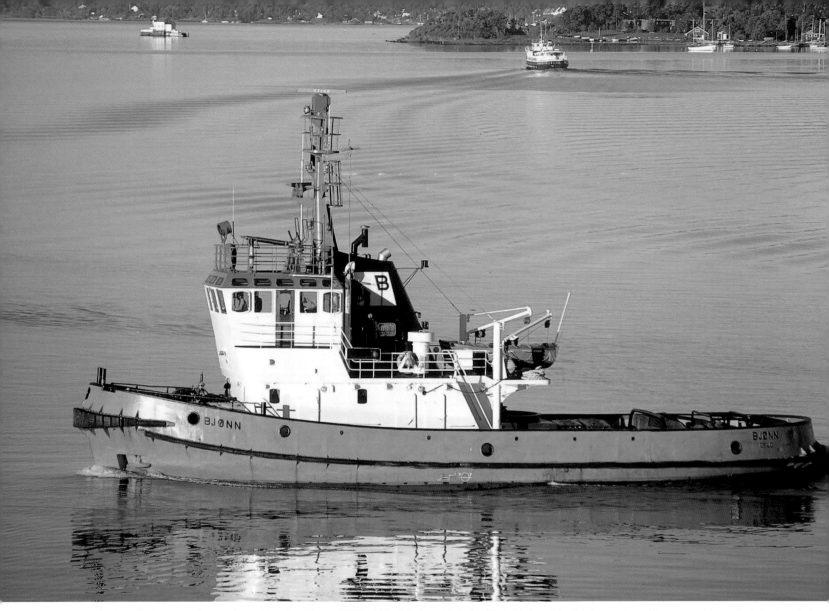

Photographed at Oslo on 22 September 1985, the **Bjønn** (NOR, 136gt/69) is owned by Buksér og Berging, a private company established in Norway in 1913. During the 1980s, the company came into the ownership of the same investment groups which acquired Röda Bolaget in Sweden. The **Bjønn** was built by Høivolds Mek. Verksted in Kristiansand and is powered by a 4-stroke 6-cylinder MaK diesel engine of 1200bhp driving a controllable pitch propeller giving her a bollard pull of 15 tonnes.

(Jim McFaul)

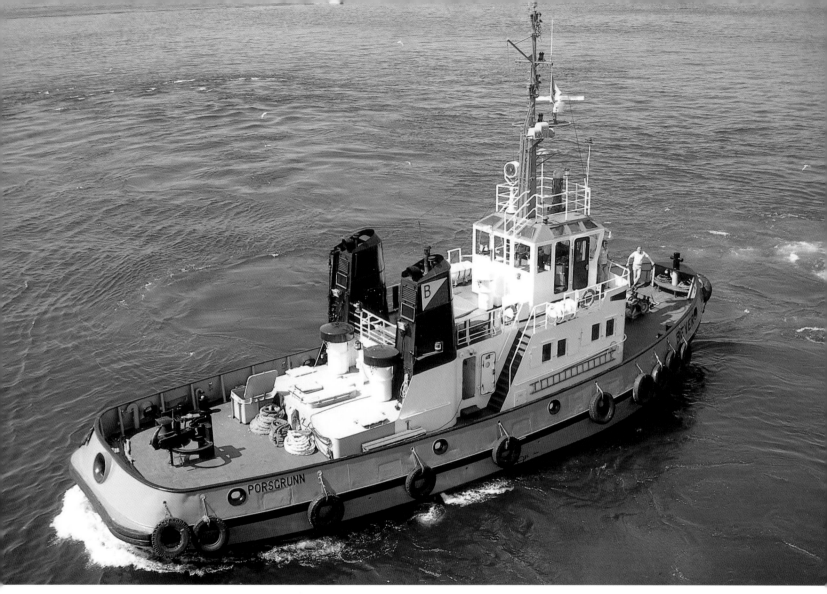

The tugs operated by Buksér og Berging are stationed at several major ports in Norway. Photographed in the capital city, Oslo, in July 1983 is the **Bever** (NOR, 184gt/74). She was built at the Mützfeldtwerft shipyard in Cuxhaven and launched as **Peter** on 29 October 1974. She was delivered to Hamburg-based Petersen & Alpers on 17 December and worked in Hamburg until 23 June 1982 when bought by Neptun Rederi, for whom Buksér og Berging act as managers. Her two 4-stroke 6-cylinder Deutz engines each of 870bhp drive two Schottel rudder propellers in Kort nozzles, and give her a bollard pull of 29 tonnes. She has since been fitted with two firefighting monitors.

(Jim McFaul)

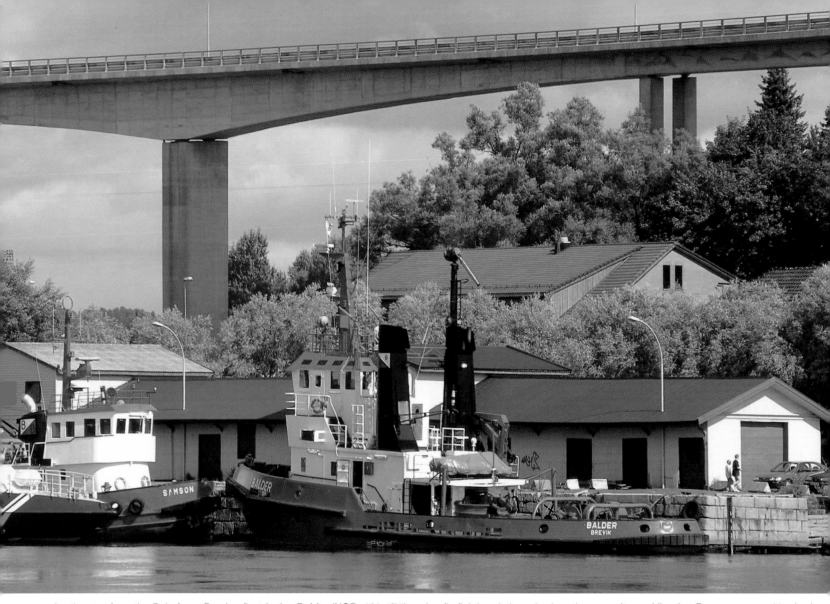

Another tug from the Buksér og Berging fleet is the **Balder** (NOR, 181gt/75) and she was photographed at Sarpsborg on 10 August 1998. A product of the Kaarbøs Mek. Verksted shipyard in Harstad, she was delivered on 18 January 1975 and is powered by a 4-stroke 12-cylinder Nohab Polar engine of 2650 bhp driving a controllable pitch propeller. She has a maximum bollard pull of 35 tonnes. For firefighting duties, she has three monitors. Like the **Bever** on page 41, she is owned by Neptun Rederi and managed by Buksér og Berging. She was stationed at Mongstad until 1988 and then moved to Brevik. In recent years she has usually been at Fredrikstad or Sarpsborg.

(Bernard McCall)

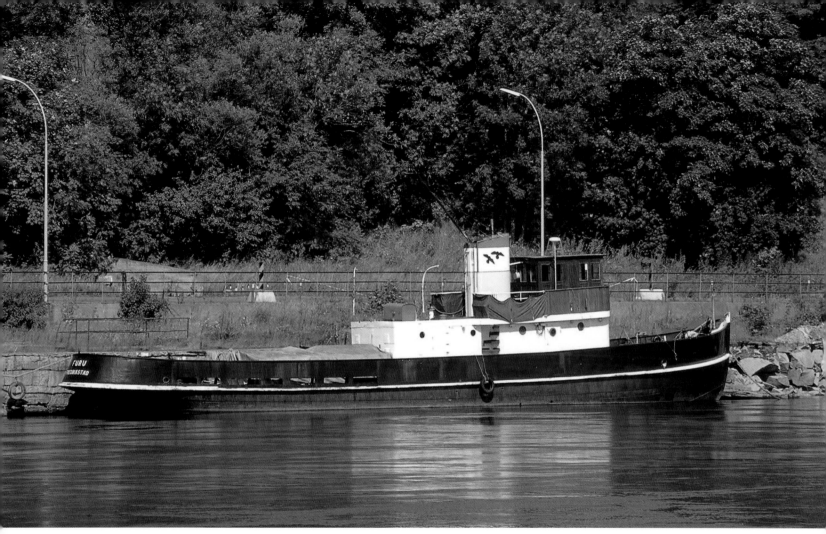

The *Furu* has an intriguing history. She was built probably as a launch in 1896 by Stettiner Oderwerke in Stettin (now Szczecin) as *Wörth* for Dittmann & Köhnke, also of Stettin. The next twenty years saw her pass through the hands of other German owners until she was sold to Danish owners in 1906 and was renamed *Carl Hansen*. In 1917, she moved to Norwegian ownership when acquired by O A Karlsen, of Fredrikstad, by whom she was renamed *Furu*. For the next two years she served the Norwegian navy as an icebreaker at Horten and was again hired by the navy in 1939 when she was rebuilt. Taken over by Germany in 1940, she served as a tender to the *Tirpitz* in Kåfjord in 1943. She was returned to her owners in May 1945. By 1950 she had been fitted with a Mirrlees diesel engine of 550bhp which had been recovered from *MMS 268* and had come into the ownership of O Paulsen AS, in Sarpsborg, who fitted her for timber towing. By the late 1970s, she was no longer in service and was sold for scrapping in Sandefjord in 1984. Soon resold, she had several owners before sinking at Fredrikstad on 22 February 1987. She was raised, however, and sold at auction in 1988. Again she was to pass through the hands of several owners, two of whom fitted new engines. In 1997 ownership passed to a preservation group and she became a restaurant at Sarpsborg where she was photographed on 10 August 1998. Her later fate is unknown.

(Bernard McCall)

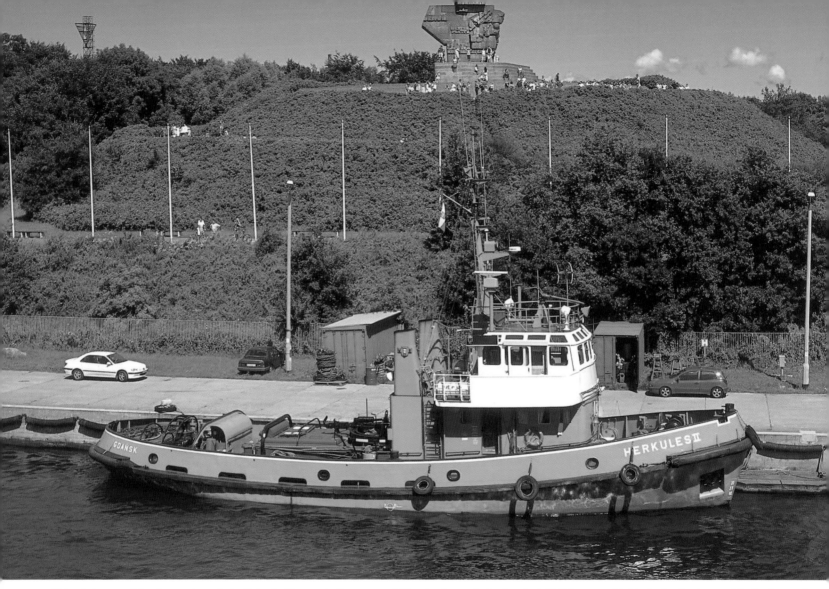

Gdansk is one of the four main ports in Poland. Towage is the responsibility of WUZ Port & Maritime Services Co Ltd which operates an interesting fleet of tugs of various ages and performance. The **Herkules II** (POL, 186gt/66), seen on 6 August 2003, was built by Svendborg Skibsværft and is driven by two 4-stroke 5-cylinder B&W engines geared to a single fixed pitch propeller and providing 1650 bhp. She has a bollard pull of 22.5 tonnes. Visible in the background is the base of a monument commemorating the start of World War 2. The monument marks the site where 182 Polish soldiers defending a nearby ammunition depot held out for 7 days against some 3500 German troops.

(Bernard McCall)

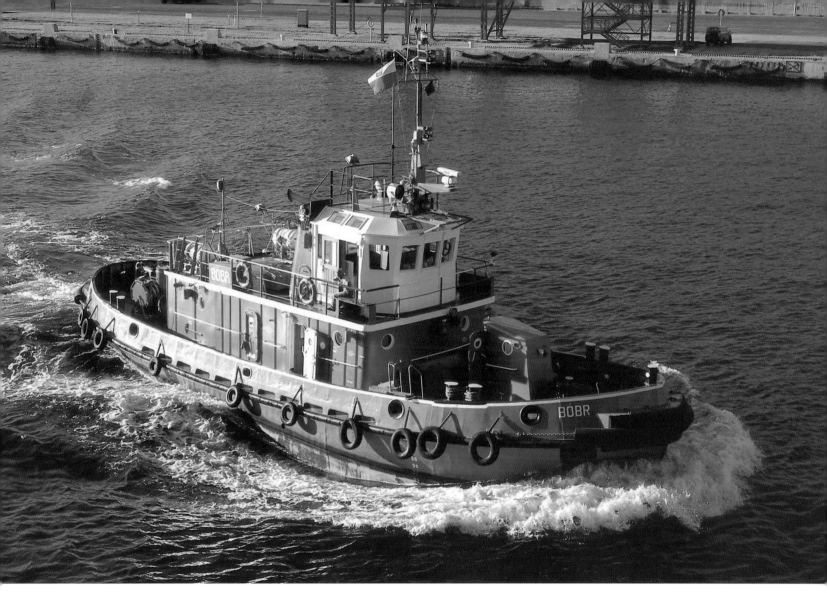

Given the domination of the Soviet Union over Poland until the overthrow of the communist regime, it is not surprising that some Polish vessels were built in Russia despite Poland's own shipbuilding strength. The Gdansk-based **Bobr** (POL, 111gt/75) is a good example, having been built by the Petrozavodsk shipyard in St Petersburg, then named Leningrad. Her two fixed pitch propellers are driven by two 4-stroke 6-cylinder engines built at Pervomaysk, also in Russia, and have a 900 bhp total power output and provide a bollard pull of a modest 10.5 tonnes. The photograph was taken on the same date as that on the previous page.

(Dominic McCall)

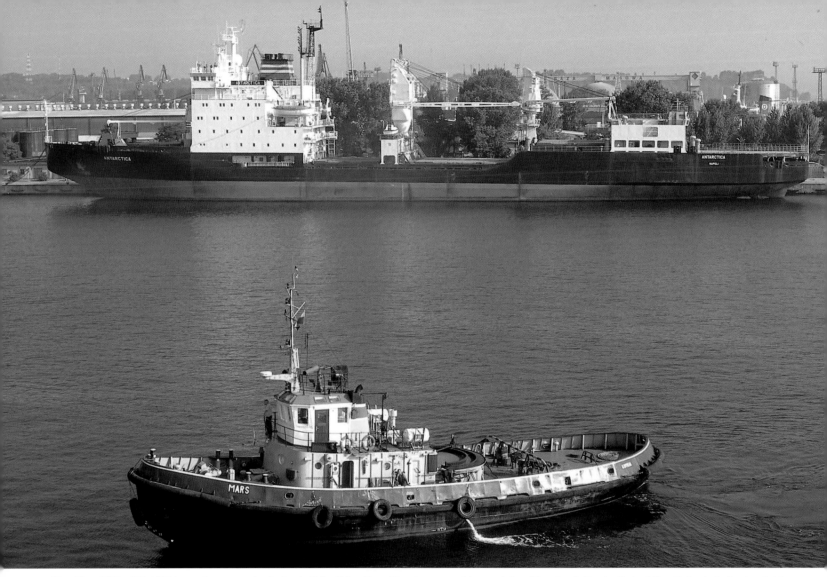

The **Mars** (POL, 179gt/77) is another example of a tug built for Poland by a Russian yard, in her case the Gorokhovets Shipbuilding Company. Both tugs are, in fact, examples of the Project 498 design (see page 4). The Petrozavodsk yard built the class between 1963 and 1975 whilst the Gorokhovets yard built its share between 1972 and 1985. The Gorokhovets tugs were an updated version of the original design and were identified as Project 498-C. The configuration of the propulsion machinery of the **Mars** is similar to that of the **Bobr**, but she is slightly more powerful. Her two 2-stroke 6-cylinder Russkiy engines drive two fixed pitch propellers and provide a total of 1200 bhp. She has a bollard pull of 17 tonnes. The photograph was taken at Gdynia on 28 July 2002. In the background is the impressive multi-purpose polar vessel **Antarctica** (ITA, 13677gt/89), ex **Stepan Krasheninnkov**-00).

(Bernard McCall)

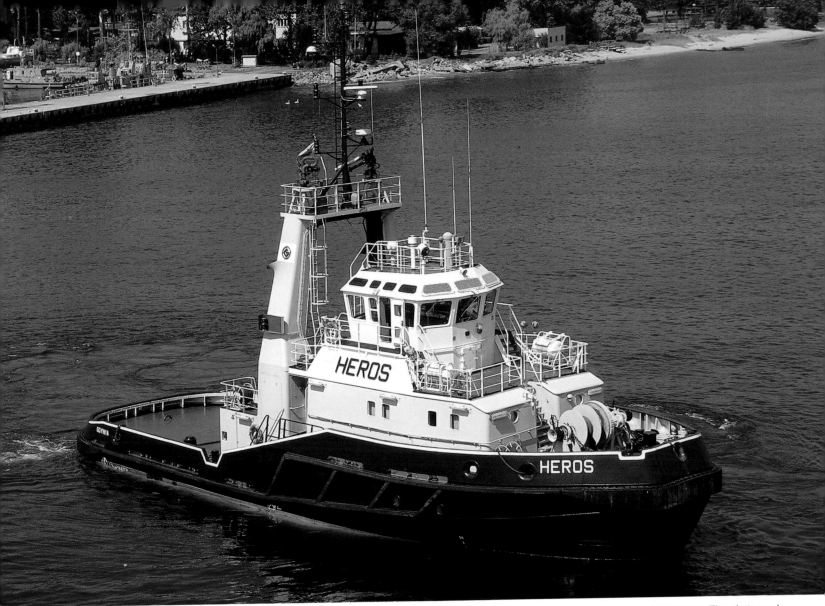

With a bollard pull of 45 tonnes, the **Heros** (POL, 365gt/98) is one of the most powerful tugs in the Gdynia-based fleet of WUZ Shipping and Port Services. Built locally by Stocznia Remontowa "Nauta", she can work as a pusher tug in addition to conventional towing. She has two directional propellers which are driven by two 4-stroke 16-cylinder Caterpillar engines with a total of 3840 bhp. The photograph was taken at Gdynia on 8 August 2002. We now leave mainland Europe for a brief look at tugs in Iceland.

(Jim McFaul)

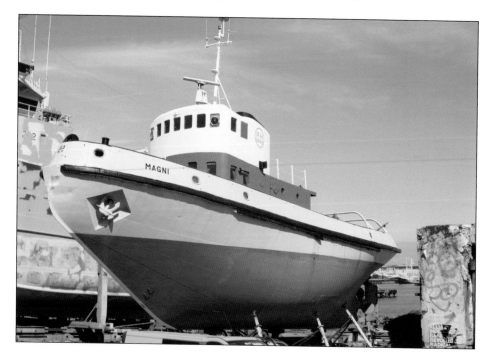

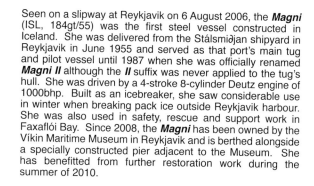

Seen on a slipway at Reykjavik on 6 August 2006, the *Magni* (ISL, 184gt/55) was the first steel vessel constructed in Iceland. She was delivered from the Stálsmiðjan shipyard in Reykjavik in June 1955 and served as that port's main tug and pilot vessel until 1987 when she was officially renamed *Magni II* although the *II* suffix was never applied to the tug's hull. She was driven by a 4-stroke 8-cylinder Deutz engine of 1000bhp. Built as an icebreaker, she saw considerable use in winter when breaking pack ice outside Reykjavik harbour. She was also used in safety, rescue and support work in Faxaflói Bay. Since 2008, the *Magni* has been owned by the Víkin Maritime Museum in Reykjavik and is berthed alongside a specially constructed pier adjacent to the Museum. She has benefitted from further restoration work during the summer of 2010.

(David Alcock)

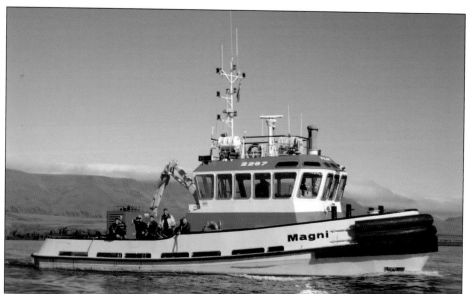

In 1996, the port of Reykjavik took delivery of a new tug called *Magni*. She is an example of the Damen Stan Tug 1906 design. Of 57gt, the tug's hull was built at Tczew in Czechoslovakia and completion was undertaken at the Damen shipyard at Gorinchem in the Netherlands. She is driven by two 6-cylinder Cummins engines, each of 640bhp, and she has a bollard pull of 17.8 tonnes. After ten years in service in Iceland she was sold to Danish owners Svendborg Bugser and was renamed *Baltsund*. Registered at Svendborg, she arrived at her new home port for the first time on 12 May 2006.

(Hilmar Snorrason)

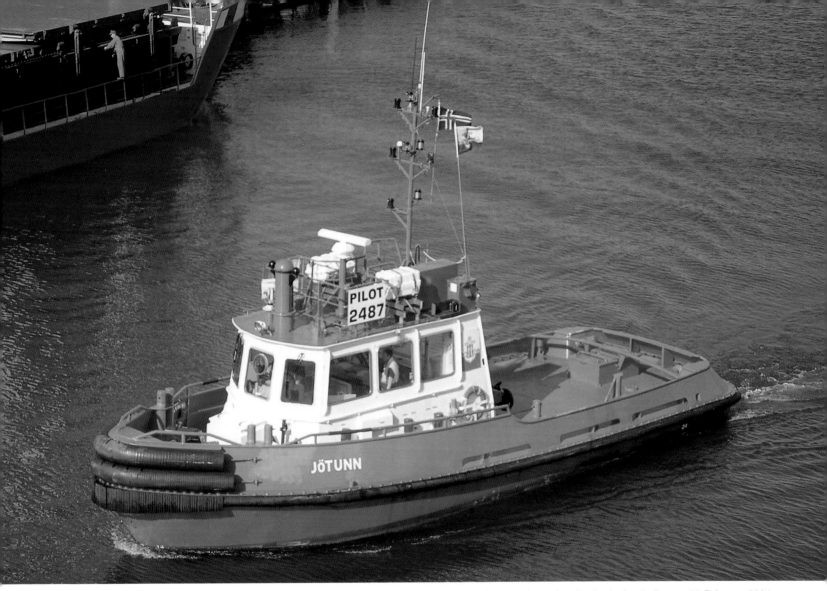

The **Jötunn** (ISL, 49gt/01) is an example of one of the many standard tug designs from the Gorinchem yard of Damen Shipyards. Her design is designated Stan Tug 1605 and she is fitted with a Cummins main engine. Used as a pilot boat as well as a tug, she was photographed at Reykjavik, Iceland's capital and main port in July 2004. The **Jötunn** was built for the Reykjavik Harbour company (now called Faxafloahafnir) and was registered under the Icelandic flag on 23 February 2001. With a newer and larger Damen standard tug of the same name due for delivery in 2008, she was sold in September 2007 to the Port of Thorlákshöfn in southern Iceland and was renamed **Ölver**. She has a bollard pull of 14 tonnes.

(Jim McFaul)

49

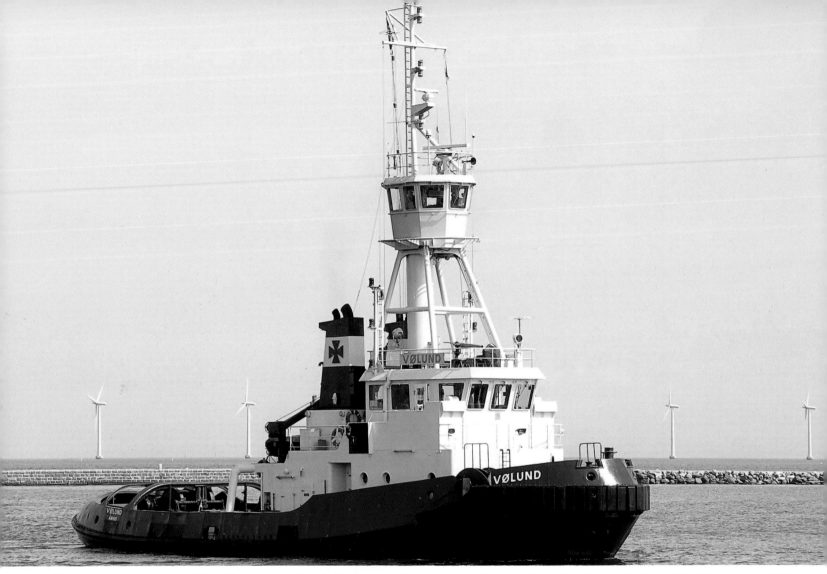

We now move on to Denmark. The Svitzer group, itself part of the huge A P Møller empire, has become a dominant force in towage both in northern Europe and elsewhere in the world. As it was initially a Danish company, it is appropriate that we see one of its tugs in the Danish capital, Copenhagen. The *Vølund* (DIS, 291gt/83) was built by Dannebrog Værft in Århus. She was launched on 27 May 1983 and delivered on 4 November. She was built as a pusher tug, the towered wheelhouse enabling the bridge team to have clear visibility above any barge that she could be pushing. Her 4-stroke 8-cylinder Wärtsilä engine of 3712bhp is geared to a controllable pitch propeller, this combination giving her a bollard pull of 55 tonnes. The photograph was taken on 12 August 2003. In 2006, she was sold to Britannia Bulk AS, of Svendborg, and was renamed *Troense II*. After the bankruptcy of this company in November 2008, she was acquired on 8 December 2008 by Vattenfall Energy Trading Services, of Copenhagen, and was renamed *VT Proton* with Svendborg as port of registry.

(Dominic McCall)

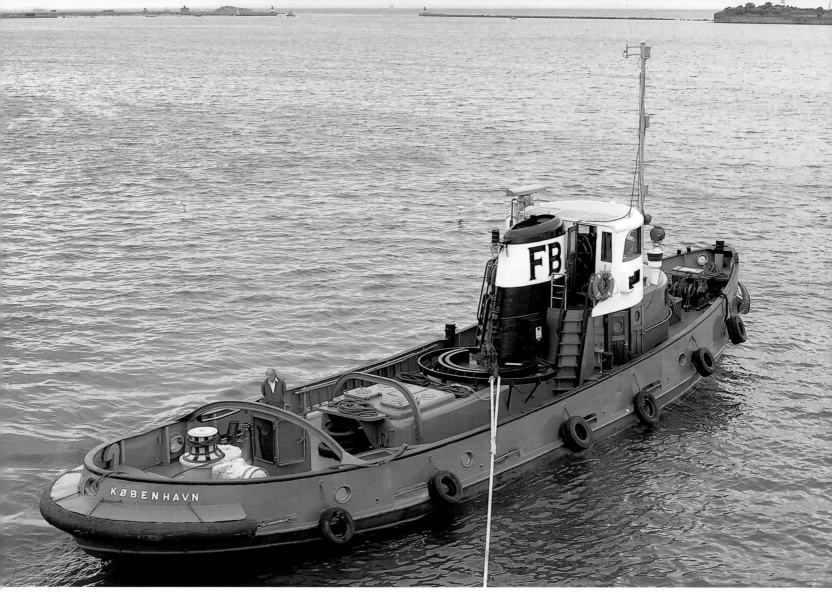

The *Tyr* (DNK, 89gt/57) is seen at Copenhagen on 13 June 1978. She was built by Abeking & Rasmussen at Lemwerder in Germany and was delivered on 2 March 1957 to Em Z Svitzers Bjergnings, of Copenhagen. She was sold to Finnish owners in February 1980 and was renamed *Taru*; a further sale within Finland to Oy Hangon Hinaus saw her become *Ilro* later in the year. In 1989 she entered the fleet of Alfons Håkans following his purchase of Oy Hangon Hinaus and this resulted in her being renamed *Castor*, a name she has retained through two further sales within Finland. She is driven by an 8-cylinder MaK engine of 920bhp and has a 13 tonne bollard pull.

(John Wiltshire)

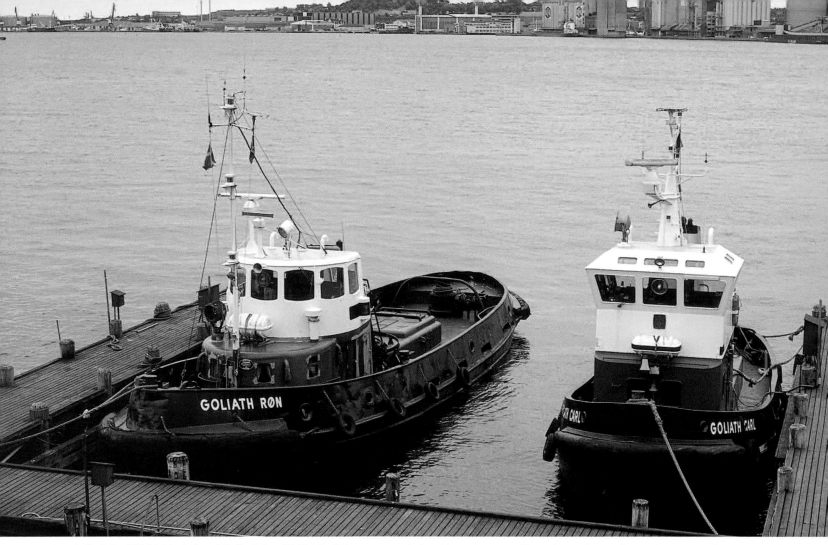

The **Goliath Carl** (DNK, 50gt/77) and **Goliath Røn** (DNK, 83gt/65) are seen at their home port of Aalborg on 2 August 1992. The **Goliath Carl** was built by Aalborg Værft and delivered to Bugserselskabet Goliath on 1 July 1977. Em. Z. Svitzers Bjergnings-Enterprise had had a significant interest in the Goliath fleet for many years and on 11 March 1993, the **Goliath Carl** was taken over by Svitzer and was renamed **Svava** with Frederikshavn becoming her home port. She is powered by a 4-stroke 16-cylinder General Motors engine and has a bollard pull of 14 tonnes. The **Goliath Røn** (DNK, 92gt/65) was built by Svendborg Skibsværft. Launched on 17 August 1965, she was delivered as **Munin** to Em. Z. Svitzers Bjergnings-

Enterprise on 2 November. On 30 September 1986, she was transferred to Bugserselskabet Goliath in Aalborg and renamed **Goliath Røn**. She was stationed in Esbjerg in 1998 but two years later was sold to owners in the Faroe Islands and renamed **Goliath**. In 2001, she was classified for ocean-going work and arrived at Port Said on 19 January 2002 after towing two pontoons from Rotterdam. On 6 January 2005 she was sold to other Faroese owners and was renamed **Thor Goliath** with Hósvík as her home port. Her engine is a 4-stroke 6-cylinder MaK of 1200bhp which provides a bollard pull of 12 tonnes.

(Bernard McCall)

There is little ship towage undertaken by the *Jacob Peter* (DNK, 69gt/62) but she is called upon to break ice in the Mariager Fjord during the winter months. She can cope with ice up to 45 centimetres thick but in more severe conditions the state-owned icebreaker *Thorbjørn* (DNK, 2164gt/90), the only such vessel able to enter the Mariager Fjord, must be summoned from Frederikshavn. The *Jacob Peter* was built at the shipyard of P de Vries Lentsch at Alphen a/d Rijn and was delivered in March 1962 to Interessantskab af A/S Ved Reberbanen og Em Z Svitzers Bjergnings Enterprise. Ved Reberbanen was one of the companies within Forende Bugserselskaber (FB) which worked in Copenhagen until December 1978 when all the shares were taken over by Svitzer. The tug has a B&W/Alpha engine of 600bhp and a bollard pull of 6 tonnes. Originally named *Gorm*, she was acquired by Fjordudvalget for Mariager Fjord on 5 April 1979 and replaced a previous tug of the same name. She was photographed on 29 July 1992 at Hadsund, one of the three communities on the Mariager Fjord and the location of a bridge across the Fjord.

(Bernard McCall)

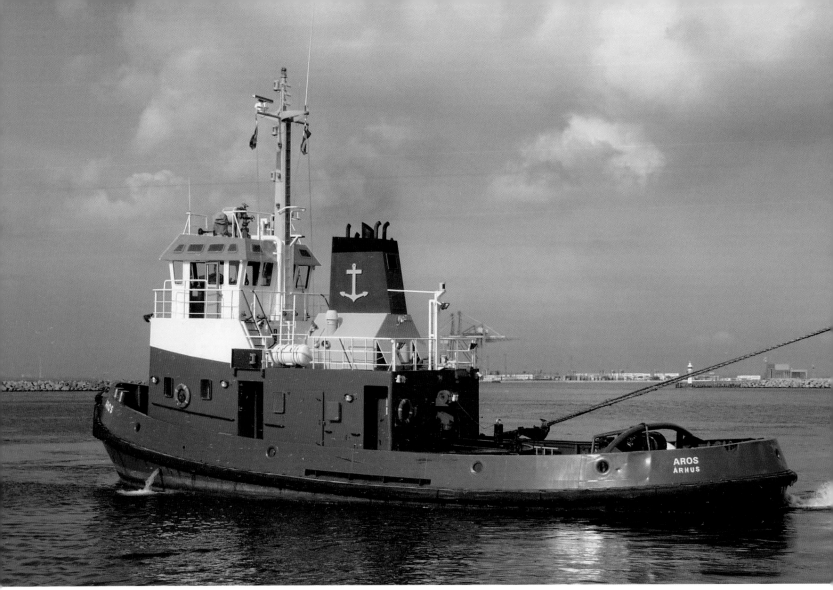

The **Aros** (DNK, 194gt/80) was built by Dannebrog Værft in Århus as **Aros To**. She was launched on 14 February 1980 and delivered on 17 April. In 1997 she was renamed **Aros** and reverted briefly to **Aros To** in 2003 when a newer **Aros** joined the Århus tug fleet. She was then transferred to the Swedish flag when bought on 17 February 2003 by the port of Karlshamn (Karlshamns Hamn & Stuveri) by whom she was renamed **Karlshamn**. Power comes from a 4-stroke 16-cylinder Alpha engine of 2480bhp which drives a controllable pitch propeller and gives her a bollard pull of 26 tonnes. Our photograph shows her in her home port of Århus on 16 May 2001.

(Bent Mikkelsen)

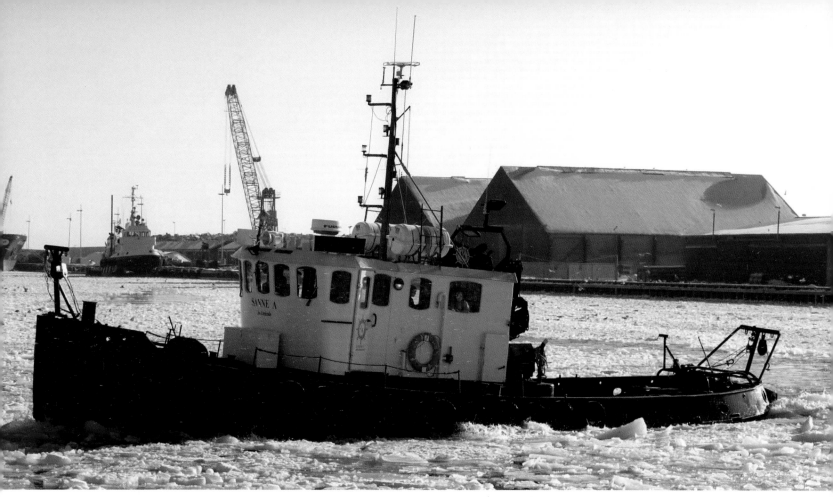

Noted on icebreaking duties at Horsens on 26 January 2006, the **Sanne A** (DNK, 33gt/1908) is yet another veteran tug. Registered at Juelsminde, she was the smallest in the three-vessel fleet of Jens Alfastsen. She was built as a steam tug at the Eriksbergs Mek. Verksted shipyard in Gothenburg as **Alert** for a Danish owner in Helsingør (Elsinore) where she was to compete with tugs of Em Z Svitzer. In 1926, she was taken over by Svitzer and in 1950 transferred to Aalborg where she worked in co-operation with the local towing company, Goliath. Prior to that, she had been converted from steam to diesel in 1949, her original 2-cylinder steam compound engine of 77 ihp being replaced by a 4-stroke 4-cylinder Alpha diesel engine of 240 bhp. In 1959 the two companies merged and she was renamed **Goliath Fur**. In 1977, she was sold to a private individual and, renamed **Fur** in July then **Ingrid Tug** in October, was based at Rudkøbing. Two years later, she was taken over by Svendborg Bugser and renamed **Lillesund** and in 1982 was re-engined

with a Caterpillar diesel engine of 365bhp which gave her a 4 tonne bollard pull. In October 1985 she was fitted with the wheelhouse from the tug **Store Ole**. Her moves around Denmark continued in 1988 when she was acquired by a contractor in Esbjerg and renamed **Else Wejse** and then in 1996, following a two-year lay-up in Nyborg, she was sold to Jens Alfastsen who renamed her **Sanne A** and undertook a major rebuild including the fitting of a new deckhouse. This sale made her the only tug ever to have been owned by the four major Danish tug operators. After a further sale within Denmark she was renamed **Mads** in 2007. Her original steam engine lives on. When removed in 1949, it was given to the technical college in Helsingør and used for training engineers in working with steam engines. Then in the 1990s, it was taken over by someone connected with the engineering college in Århus. He restored it and it is now on display in the entrance lobby of that college.

(Bent Mikkelsen)

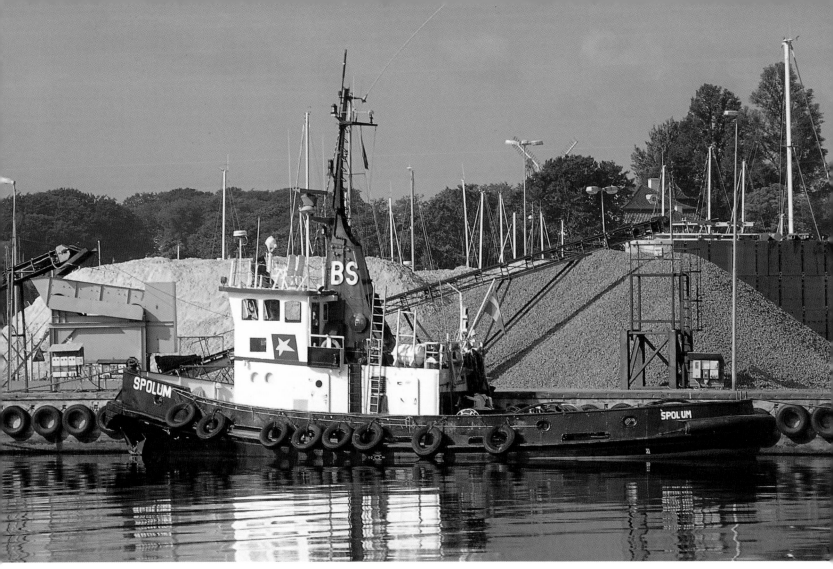

The completion of the Great Belt Bridge in Denmark sadly meant the demise of the splendid ferries that used to cross this stretch of water. The construction of the bridge was a huge feat of civil engineering and required vessels of many different kinds including tugs. Berthed at Nyborg on the western side of the Great Belt on 3 August 1993 is the **Spolum** (DNK, 70gt/70). Launched on 30 December 1969, she began life as **Argus 8** built by Gutehoffnungshütte Sterkrade at Walsum on the River Rhine for Hamburg-based Harms Bergung to whom she was delivered on 12 February 1970. In August 1989, she was purchased by Bruno Spolum, of Frederikshavn, and was renamed **Spolum**. In 1997 she was fitted with a new 4-stroke 8-cylinder Deutz engine of 1600bhp which gave her a 21 tonne bollard pull compared to 16 tonnes of her original Deutz engine. In late December she was renamed **Vlieland** after sale to a Danish owner based on Vlieland.

(Bernard McCall)

With one or two notable exceptions, ports in the UK have become no-go areas for the general public. Elsewhere in Europe a more enlightened outlook enables ports of all sizes to hold community events which are immensely popular and enable the ports to maintain a vital connection with the population of the areas they serve. An excellent example is the port of Vejle in Denmark which hosts a steam festival every two years. The **Jeppe Jensen** (DNK, 50gt/65) was photographed on 8 July 2006 as she escorted the former icebreaker **Wal**, built in 1938 for service on the Kiel Canal and now preserved as part of the maritime museum in Bremerhaven. The tug takes her name from the man who surveyed Vejle Fjord and made detailed plans for a new port which opened in 1827. She was built by Søby Motorfabrik & Stålskibsværft and is powered by a B&W Alpha diesel engine which provides a 4.1 tonne bollard pull.

(Bernard McCall)

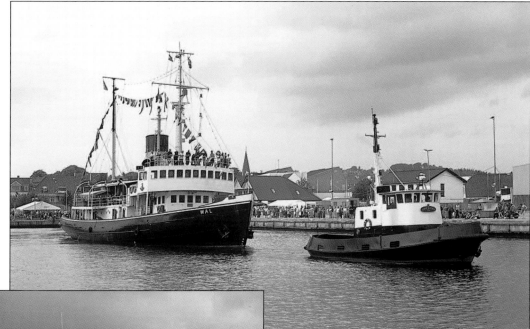

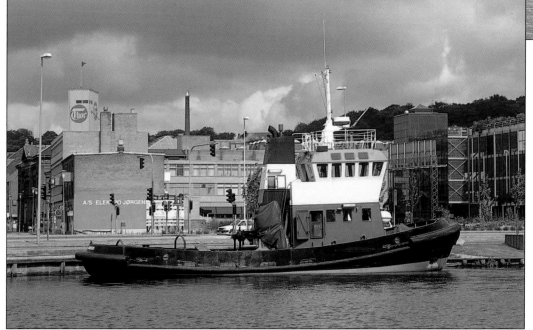

Assens Skibsværft in Denmark had been a prolific builder of trawlers during the 1970s but later in that decade orders dried up and no ships were delivered in 1979 and just a single tug in 1980. The **Jens Ove** (DNK, 60gt/81) was the first of two tugs delivered in 1981 and is notable for the size of her superstructure. Powered by a B&W Alpha diesel engine of 900bhp, she is owned by the port authority in Randers and she was photographed at this port on 4 August 1992. She entered service in January 1981 and replaced the veteran **Bjørn** which had served Randers since 7 February 1909 and which is now preserved at Helsingør (Elsinore).

(Bernard McCall)

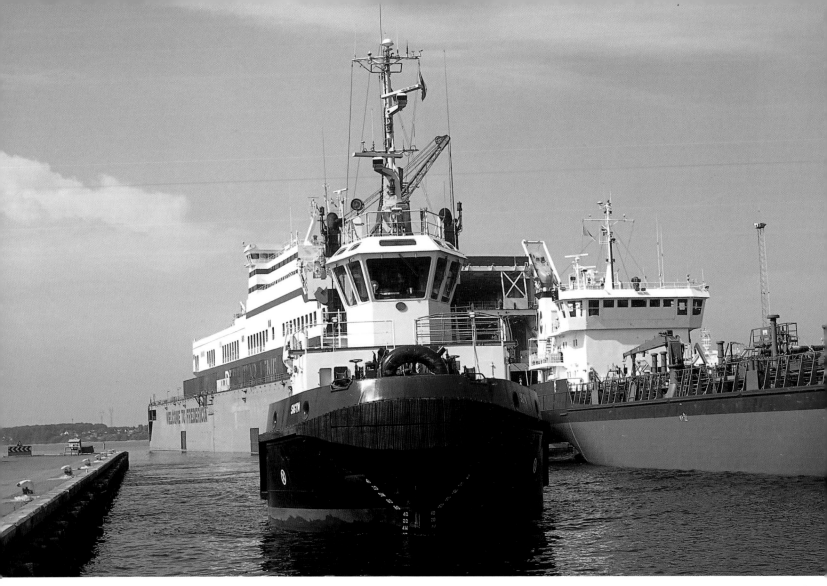

The **Sigyn** (DIS, 485gt/96), the second in a pair of tugs ordered by A/S Em Z Svitzer, is a significant vessel in the history of Danish shipbuilding because she was the last vessel to be built by Svendborg Værft at the end of its 90-year history as a shipbuilder. Power comes from two 4-stroke 6-cylinder MAN B&W engines, each of 1998bhp, which drive two Aquamaster azimuthing thrusters geared to two Z propellers. This combination provides a bollard pull of 51 tonnes. We see her at Fredericia on 6 July 2006 when she had just assisted at the stern of the tanker **Clipper Helle** (DIS, 1716gt/91) from the repair yard to the quay at the right hand side of the photograph. The tug's captain was determined to show off the tug's capabilities and brought his vessel up close to the photographer in the confined space of the wet dock.

(Bernard McCall)

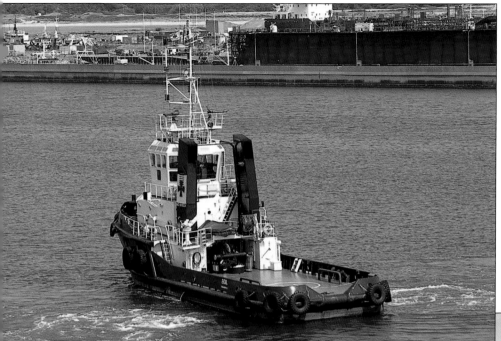

Although comparatively young, the *Egil* (DNK, 376gt/87) has had an interesting career. She was one of a pair of tugs built at Selby by Cochrane Shipbuilders Ltd for a subsidiary of Cory Towage which had won a contract to supply towage services at the Puerto Armuelles oil terminal in Panama. Launched on 28 May 1987 and delivered on 30 July, she was named *Maria Isabel* and was to work under the flag of Panama. It was discovered that there was already a Panamanian vessel thus named so the suffix *I* was added to her name after trials and before entry into service. When replaced after a decade of service, she was chartered by Smit International for work in the Panama Canal area. In March 1998, she was sold to Danish operator Nordane Shipping which required a tug for a newly-won contract at Kalundborg and she was renamed *Stevns Bugser*. Two years later, she was acquired by another Danish operator, Em Z Svitzer, and renamed *Egil*. By coincidence, this company was later to acquire the Cory Towage fleet. She is powered by two 4-stroke 6-cylinder Ruston engines, of 4340bhp in total, which drive two directional propellers and give a bollard pull of 60 tonnes. Taken at Esbjerg on 5 July 2006, this photograph shows that she is an anchor-handling and firefighting tug.

(Bernard McCall)

he *Alice Bekker* (DNK, 127gt/59) was built at the Theodor uschmann shipyard in Hamburg. Launched on 30 June 959 she was handed over on 21 November to Richard orchard's 'Fairplay' fleet in Hamburg as *Fairplay II*, ecoming *Fairplay VII* on 18 December 1972. By the late 980s, she was used only as a reserve tug. In 1991 she was old to a dealer in Westerbroek and laid up there for re-sale nder the name *Hirta*. She was bought by German owners d renamed *Selene* with Rostock as port of registry. She as apparently being used for drug trafficking and arrived in sbjerg on 22 September 1993 after being pursued by French astguards. The crew quickly disappeared. In 1994 she as bought by Bjarne Bekker and renamed *Alice Bekker*. is photograph was taken on 11 July 2006 as she left the port Esbjerg with a Dutch barge. By this time, she had left onduran registry and come into the Danish register with sbjerg as her home port. Her single 4-stroke 8-cylinder MAN gine of 1240bhp drives a controllable pitch propeller in a rt nozzle. She has a bollard pull of 19 tonnes. She became onja in 2007 following a sale within Denmark and at the time writing has been on long term charter in northern Norway ar the Snovitt gas field.

(Bernard McCall)

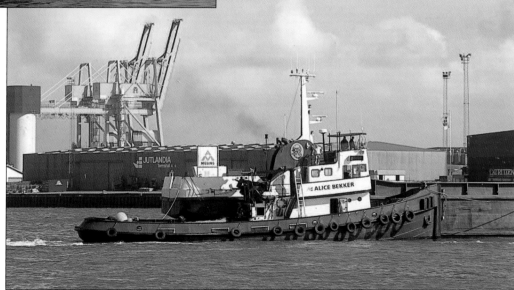

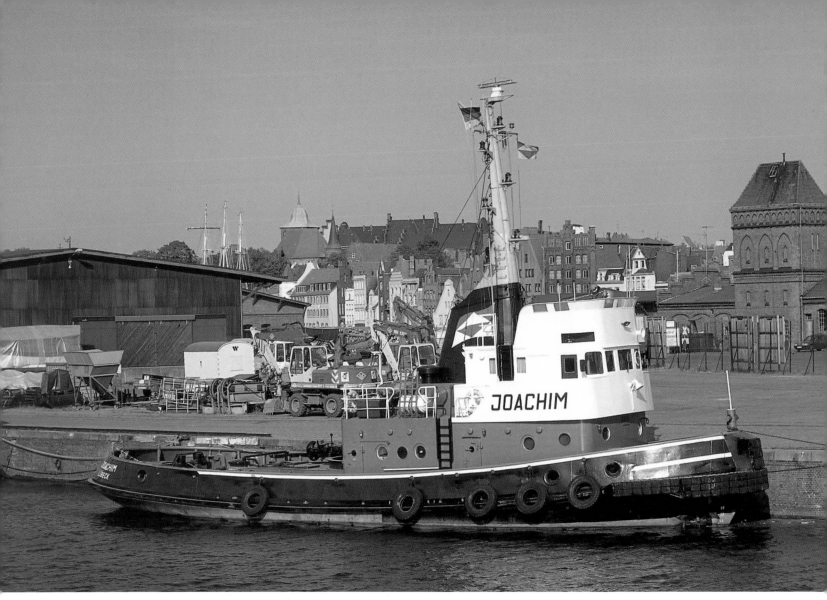

The **Joachim** (DEU, 142gt/68), photographed at Lübeck on 26 May 1992, typifies German tug design of the 1960s. She was built by Elsflether Werft as **Rechtenfleth** and, having been launched on 27 September 1968 was handed over to owners Unterweser on 18 October. She entered the Lübeck-based fleet of J Johannsen & Sohn in May 1985. She served this company for a decade before being sold to the port of Papeete in French Polynesia where she continues to work as **Aito II**. Her 4-stroke 8-cylinder Deutz engine of 1320 bhp drives a fixed pitch propeller in a Kort nozzle and she has a bollard pull of 41 tonnes.

(Bernard McCall)

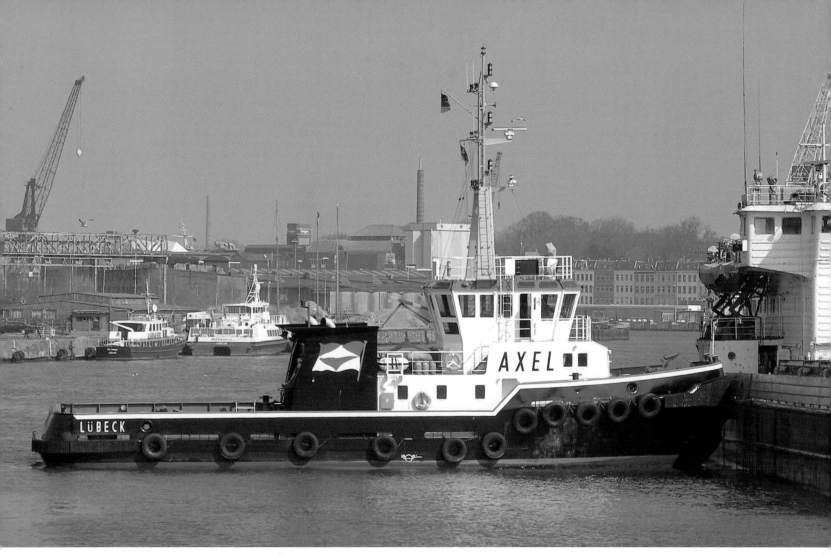

The port of Lübeck, some 12 miles (19 kilometres) from the mouth of the River Trave at Travemünde, has several wharves, some of which are near the centre of the beautiful city. Trade at the innermost wharves is dominated by exports of round timber and the **Vuoksa** (RUS, 2426gt/78), about to leave on 2 April 1999 having loaded such a cargo, is being assisted by the **Axel** (DEU, 305gt/90), owned locally by J Johannsen & Sohn, a company established in 1896. The company had always bought secondhand tugs but in the late 1980s, faced with an urgent requirement for a new and more powerful tug to handle the new generation of ferries visiting Travemünde and sailing upriver, it could find nothing suitable and consequently ordered its first newbuilding. The **Axel** (DEU, 305gt/90) was built at the J G Hitzler shipyard in Lauenburg and launched on 22 September 1990. She was handed over to her owner on 18 October. Power comes from two 4-stroke 6-cylinder Deutz engines, each of 1754bhp, which drive two Schottel propellers, this combination providing a bollard pull of 41 tonnes.

(Bernard McCall)

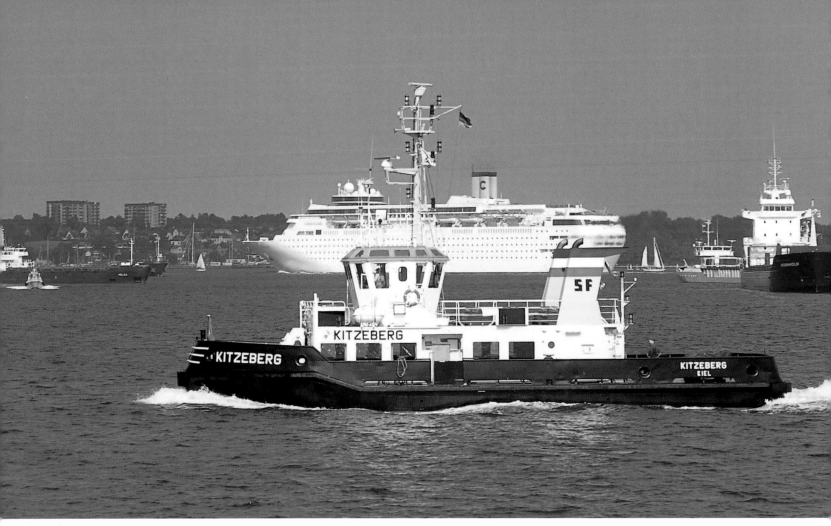

Readers visiting Kiel are urged to sample a round trip on the Kieler Förde. There is much of maritime interest to be seen. The waterbus service is operated by a fleet of smart ferries owned by Schlepp- und Fährgesellschaft Kiel mbH (SFK), a company established in 1996 and known prior to that as Kieler Verkehrs-AG. In busy periods, and when shipping movements permit, some of the company's tugs, always kept in immaculate condition, also operate the passenger service. The **Kitzeberg** (DEU, 201gt/92) is such a dual purpose vessel, her passenger saloon being clearly visible. She has a certificate for 180 passengers (120 in winter) and 80 bicycles. She was to have been built at the Hamburg yard of Johann Oelkers but that company's bankruptcy after the delivery of sister tug **Falckenstein** resulted in the order being transferred to the Nobiskrug shipyard in Rendsburg. Subsidies granted for the tug's construction were dependent on the order being given to a yard in Schleswig-Holstein. The **Kitzeberg** was launched on 25 April 1992 and handed over on 28 May. By a happy coincidence, she was yard number 750 and was delivered in the year of Kiel's 750th anniversary. Power comes from two 4-stroke 6-cylinder MWM engines, each of 897bhp which drive two Schottel propellers and give a bollard pull of 25 tonnes. This busy scene at Holtenau on 24 June 2006 shows the cruise liner **Costa Classica** outward bound from Kiel in the Kieler Förde and four coasters approaching the locks to enter the Kiel Canal.

(Bernard McCall)

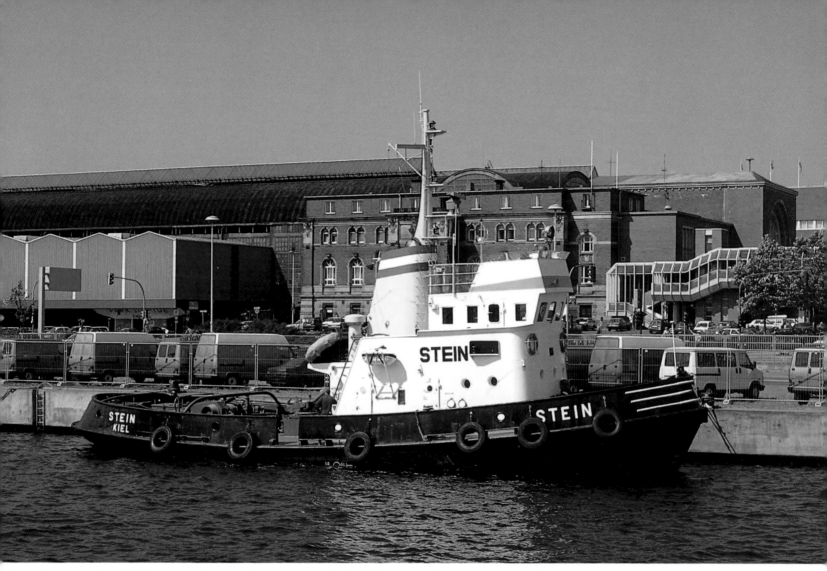

An earlier generation of Kiel tug is depicted in this view of the **Stein** (DEU, 122gt/69), built by D W Kremer Sohn at Elmshorn. She was handed over to her owners on 6 November 1969. She is powered by a 4-stroke 6-cylinder MWM engine of 1100 bhp driving a fixed pitch propeller in a Kort nozzle. This gave her a bollard pull of 18.5 tonnes. At the date of this photograph, 31 July 1991, the tugs used a berth very near to the city centre prior to a move a few hundred metres up the dock that was caused by redevelopment of this entire quayside area in the early years of the present century. The arch of the railway station roof can be seen in the background. From this quay depart the Kieler Förde passenger ferries and also cruises to the Kiel Canal. Nearby are berths for cruise liners and ferries to Scandinavia, making this an ideal location for shipping enthusiasts. On 9 July 1998, the **Stein** was sold to Danish owners Svendborg Bugser A/S and was renamed **Storesund**.

(Bernard McCall)

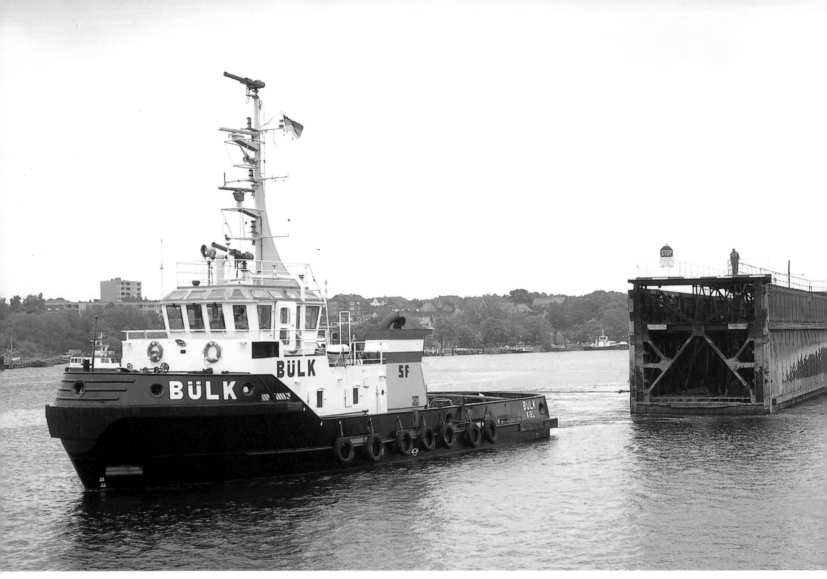

A comparatively rare view of one of the lock gates at Holtenau being moved from the locks to an adjacent quay on the southern bank of the Canal on 24 July 1996. Here gates undergo routine and emergency maintenance, and spare gates are available if required as a result of an incident. The *Bülk* (DEU, 263gt/87) was built at the Johann Oelkers shipyard in Hamburg. Launched on 10 August 1987, she was handed over to her owners only 19 days later. Her two 4-stroke 8-cylinder MWM engines are geared to two Schottel propellers in Kort nozzles and provide 3154bhp. She is also fitted with a bow thruster which can be used when working in the narrow confines of the Canal. Her bollard pull is 40 tonnes. She is designated as an emergency towing vessel and so is not permitted to sail more than 15km westwards along the Kiel Canal in case she is required for emergency duties in the Kieler Förde and Baltic.

(Bernard McCall)

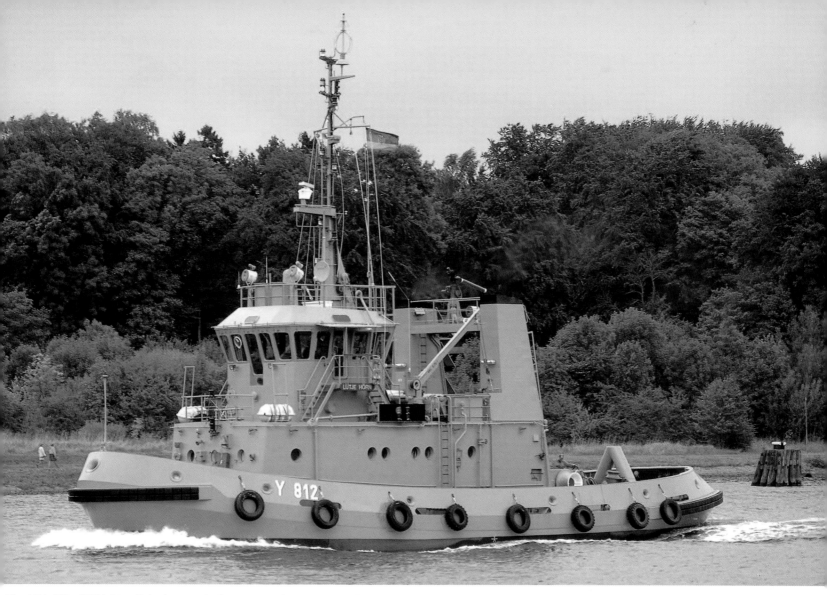

The *Lütje Hörn* (DEU, 277gt/90), photographed on passage through the Kiel Canal on 3 September 2000, is one of six Type 795 Nordstrand-class harbour tugs working for Germany's Bundesmarine. She was built at the Husumer shipyard and was launched on 12 April 1990 with delivery to the Bundesministerium der Verteidigung being made the following month. Power comes from two 4-stroke 6-cylinder Deutz MWM engines, each of 1100bhp, geared to two Voith-Schneider propellers. She is attached to the German naval base at Eckernförde, north of Kiel, and on 28 April 2004 she towed submarine *U21* from Kiel to Eckernförde where the latter vessel will be part of a museum.

(Bernard McCall)

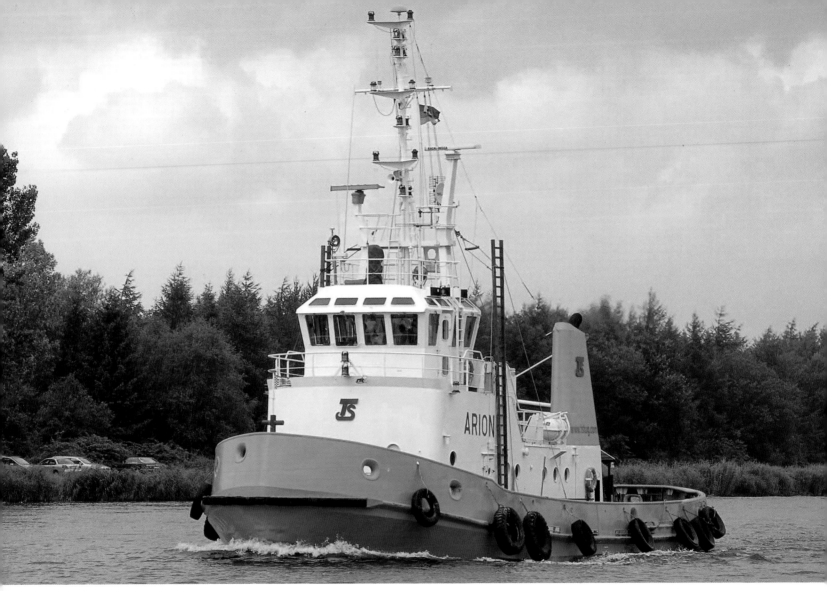

Making her way along the Kiel Canal on 23 July 2002 is the **Arion** (DEU, 257gt/78). Built at the Jadewerft shipyard in Wilhelmshaven, she was laid down on 15 May 1978, launched on 28 October, and delivered to her owners, Hapag-Lloyd Transport & Service, on 22 December 1978. She has two 4-stroke 8-cylinder MaK engines with a total power output of 2702 bhp which drive two Voith-Schneider propellers. This combination gives her a bollard pull of 34,5 tonnes. In this view she is wearing Hapag-Lloyd colours but this company was the subject of mergers and takeovers during which the towage business was sold and the **Arion** is now in the Bugsier fleet and carries the colours of that company.

(Dominic McCall)

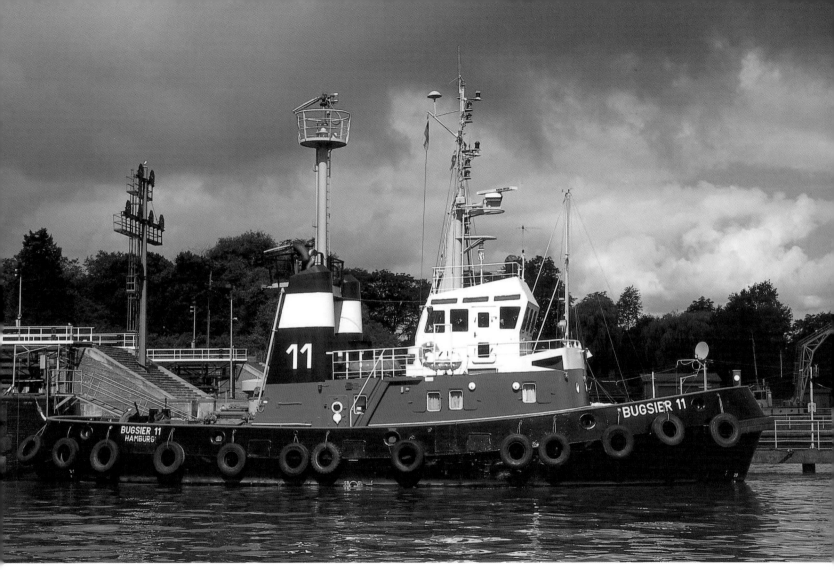

It is essential that there is towage assistance readily available at the western end of the Kiel Canal in addition to the eastern end, even though this may mean long periods of inactivity for the tug and her crew. Storm clouds are threatening as we see the **Bugsier 11** (DEU, 181gt/77) moored alongside the locks at Brunsbüttel on 28 July 1996. This tug is one of a group of several basically similar tractor tugs built for the Bugsier company at the Max Sieghold shipyard in Bremerhaven between 1972 and 1979. She differs from her sister vessels in having specialist fire fighting equipment. A remote controlled periscope monitor 21 metres above the water is clearly visible in this view and just visible near the funnel is another monitor 9 metres above the water. She is also fitted with "watercurtain" facilities for self-protection during close range fire fighting. She is powered by two 4-stroke 6-cylinder Deutz engines totalling 1740 bhp and driving two directional propellers. This gives her a bollard pull of 30 tonnes.

(Bernard McCall)

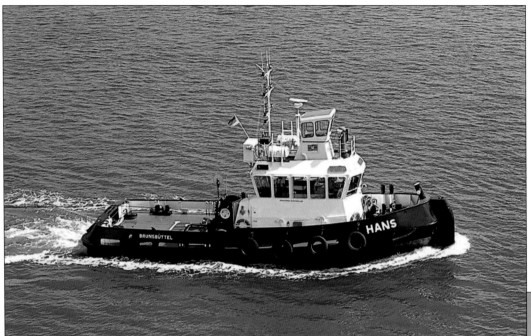

In addition to the large shiphandling tugs, the German rivers see a wide variety of smaller multipurpose tugs that can be used for handling barges and civil engineering duties in addition to manouevring smaller ships in confined dock areas. The **Hans** (DEU, 70gt/98), passing Cuxhaven on 12 August 2005, is a good example. Her hull was built at the Gdansk shipyard of Stal Rem S.A. with completion at the K Damen shipyard in Hardinxveld-Giessendam. A bollard pull of 22 tonnes is generated by her two 4-stroke 12-cylinder Caterpillar 3412 C-TA engines with a total output of 1460bhp. Germanischer Lloyd gives her launch date as 10 October 1997 with completion in February of the following year. She is one of five tugs currently (2010) in the fleet of Hans Schramm, based in Brunsbüttel.

(Bernard McCall)

The port of Cuxhaven is the base for the tug fleet of Otto Wulf which acquired its first tug in 1922. Since that time, it has maintained a small fleet of tugs for towage duties at Cuxhaven and in the lower reaches of the Elbe and also for contract towage throughout northern Europe. Although some tugs have been newbuildings, most have been relatively modern second-hand acquisitions. A good example is the **Taucher O. Wulf 8** (DEU, 92gt/70), photographed passing Cuxhaven on 29 August 2005. She was built at the Mützelfeldtwerft shipyard in Cuxhaven for Lütgens & Reimers, of Hamburg. Named **Escort**, she was launched on 10 July 1970 and delivered on 4 August. In April 1994, she entered the Otto Wulf fleet and was initially positioned in Rostock. As built her gross tonnage was listed as 84grt but this was amended to 92gt in 1995. She was originally powered by a 4-stroke 6-cylinder MaK engine of 500bhp but this was replaced in 1999 by a 4-stroke 12-cylinder Cummins engine of 1400bhp which improved her bollard pull from 10,2 tonnes to 17 tonnes.

(Bernard McCall)

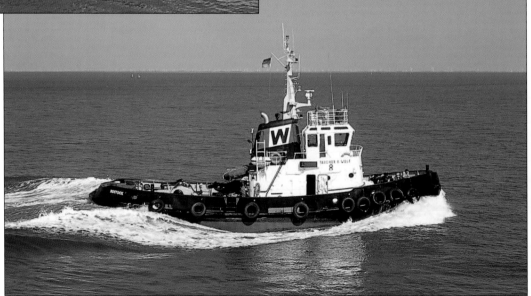

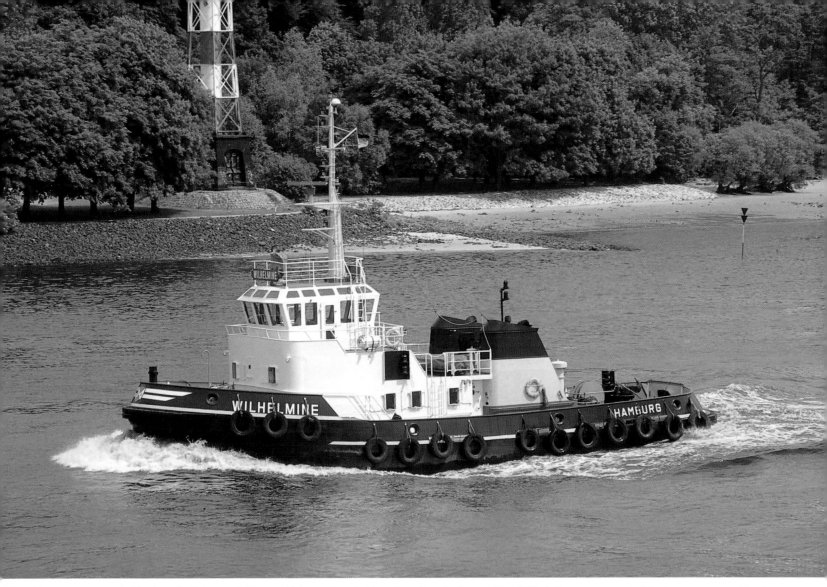

The oldest tug operator in Hamburg is Petersen & Alpers which was founded in 1793. The *Wilhelmine* (DEU, 207gt/80) was built at the Cuxhaven yard of Mützelfeldtwerft. She was launched on 1 July 1980 and delivered to her owners on 11 November of that same year. Unable to hold out against imminent competition from tug operators elsewhere in Europe, notably the Netherlands, owners in Hamburg looked at ways of cutting costs and it was decided to reduce tug crews from four to three. The *Wilhelmine* was converted to three-man operation in October 1986. Powered by two 4-stroke 6-cylinder Deutz engines each of 870bhp which drive two Schottel rudder propellers in Kort nozzles, she has a 30 tonne bollard pull. She is seen in the River Elbe on 1 June 1989.

(Bernard McCall)

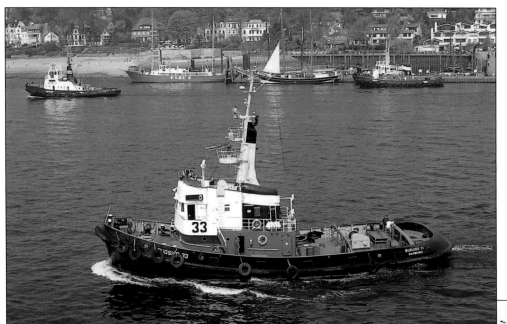

In 1952, the four major towage companies then working in Hamburg signed a Joint Service Union, the origins of which dated back to 1936 when an increase in traffic through Hamburg resulted in a work-sharing agreement. The 1952 Union resulted in a single operations centre from which work was allocated according to the share of tugs that each company had contributed to the Union. In that same year, Bugsier, hitherto operators of deepsea and salvage tugs, began towage operations in Hamburg in competition with the Joint Service Union. Three years later, Bugsier and the Union came to an agreement that Bugsier would have 30% of the work and the Union 70%. The **Bugsier 33** (DEU, 181gt/69) was the second of a pair of tugs built at the F Schichau shipyard in Bremerhaven. She was launched on 21 April 1969 and delivered on 11 November of that year. Her 4-stroke 8-cylinder Deutz engine of 1500bhp drives a fixed pitch propeller in a Kort nozzle and provides a bollard pull of 25 tonnes. She is seen in the River Elbe on 1 June 1989. In 1993, she was sold to Latvian operators for service at Liepaja and was renamed **Namejs**.

(Bernard McCall)

The **Hermes** (DEU, 296gt/76) was photographed at Hamburg on 31 May 1995. She was the second of a pair of tugs built for Bugsier at the Max Sieghold shipyard in Bremerhaven. Handed over to her owners on 16 October 1976 as **Bugsier 9**, she was renamed **Hermes** only a year later on 10 October 1977. Her two Deutz engines each of 1800bhp are geared to two Schottel rudder propellers in Kort nozzles and provide a bollard pull of 40 tonnes. This makes her suitable for salvage work in addition to harbour towage and indeed sistership **Bugsier 8** sank after striking a reef while on a salvage operation in 1977. In early January 1997 she was taken on charter to work at Thamesport on the River Medway but left on 27 March to go to Falmouth where she took up station as a salvage tug for a month. In 2004, she was sold to Danish owner Jens Alfastsen and renamed **Luna A**.

(Bernard McCall)

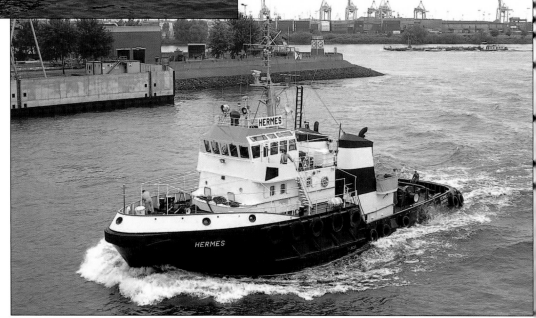

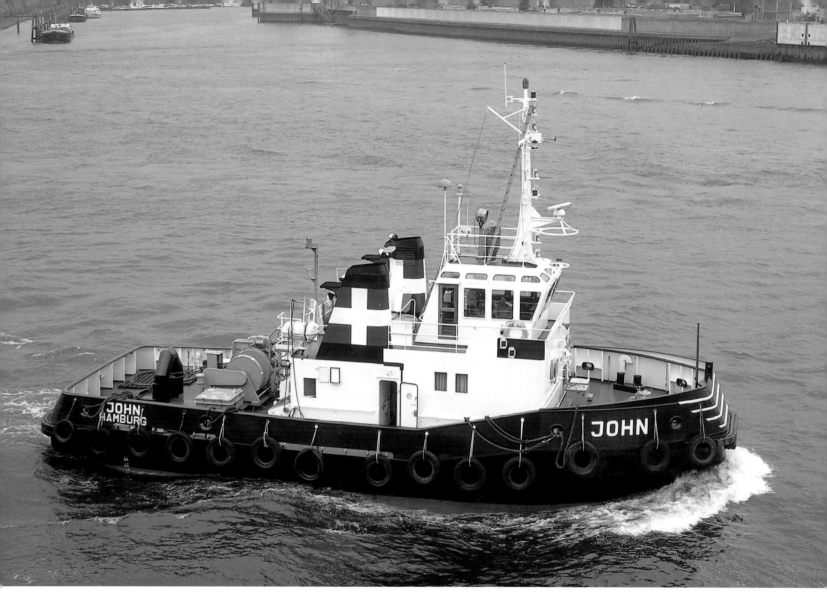

The **John** (DEU, 159gt/78) was built at the Johann Oelkers shipyard in Hamburg where she was launched on 30 December 1978. On 27 February 1979 she was handed over to Neue Schleppdampschiffsreederei Louis Meyer, the smallest of the five major tug fleets in Hamburg. Photographed at Hamburg on 31 May 1995, she was the first new tug built for the company. In 1997 she was one of four Hamburg tugs transferred to a company in Lithuania. She hoisted that country's flag and was renamed **Tak-3** for service at Klaipeda. Power comes from two 4-stroke 12-cylinder Deutz engines with a total of 1468bhp which drive two Schottel rudder propellers in Kort nozzles and give her a bollard pull of 21 tonnes.

(Bernard McCall)

71

The European Community rules about competition and freedom of trade within and between member countries has permitted large towage companies to expand horizons into other countries. This process has not always been popular because it has challenged traditional ways of working. The large ports, in particular, have seen the arrival of new fleets. Dutch operator Kotug International B.V. has had tugs working in Hamburg since 1996. The **RT Innovation** (NLD, 449gt/99), photographed there on 26 August 2000, is one of a quartet of sister vessels shared between two yards in Spain and is the second of the pair built by S. A. Balenciaga in Zumaya. A powerful tug, she has three 4-stroke 16-cylinder Caterpillar engines, each of 2129bhp, which are reduction geared to three directional propellers, two forward and one aft. She has a bollard pull of 78 tonnes. The design, known as a Rotortug, with its three azimuthing propulsion units, offers great manoeuvrability and is especially suited for escorting large tankers and assisting high windage vessels such as vehicle carriers and container ships in confined waters. As such ships predominate in Bremerhaven, it was no surprise when the **RT Innovation** was transferred there.

(Bernard McCall)

We see two tugs at the landing stage in Hamburg to which local tugs are moored whilst they await their next turn of duty. Fairplay Schleppdampfschiffs Reederei is one of the five leading towage companies originally based in Hamburg and was established by Richard Borchard in 1905. The **Fairplay VI** (DEU, 225gt/92), photographed on 31 May 2000, is a product of the Mützelfeldtwerft shipyard in Cuxhaven, being launched on 8 October 1991 and delivered in February 1992. Her two 4-stroke 6-cylinder Deutz engines are geared to two Schottel directional propellers and provide power of 3085bhp. This combination achieves a bollard pull of 41 tonnes. Her Rostock port of registry should be noted. She and **Fairplay VII** were intended to be placed permanently at that Baltic Sea port in order to serve ports such as Warnemünde and Wismar in addition to Rostock following the reunification of Germany.

(Bernard McCall)

Another company involved in the Joint Service Union is Lütgens & Reimers. Taken over by HAPAG in 1920 of which it was then a subsidiary company, difficulties arose within HAPAG in 1958 and the tugs passed to Bugsier along with a 20% share of the Joint Service Union. Following the expiry of the arrangement after a decade, during which it was banned from shiphandling work on the Elbe, Lütgens & Reimers was allowed to rejoin the Union. The **Exact** (DEU, 218gt/83) was built at the Detlef Hegemann Rolandwerft shipyard on the River Weser as **Grohn** for Unterweser to whom she was handed over on 29 September 1983. She is powered by two 4-stroke 6-cylinder Deutz engines each of 1088bhp and geared to two Voith-Schneider propellers. This gives her a bollard pull of 25 tonnes. She became **Exact** in 1998 when transferred from Unterweser to Lütgens & Reimers but reverted to **Grohn** in 2002. Lütgens & Reimers is a wholly-owned subsidiary of Unterweser, both being parts of a larger owning group. The photograph was taken on 26 August 2000.

(Bernard McCall)

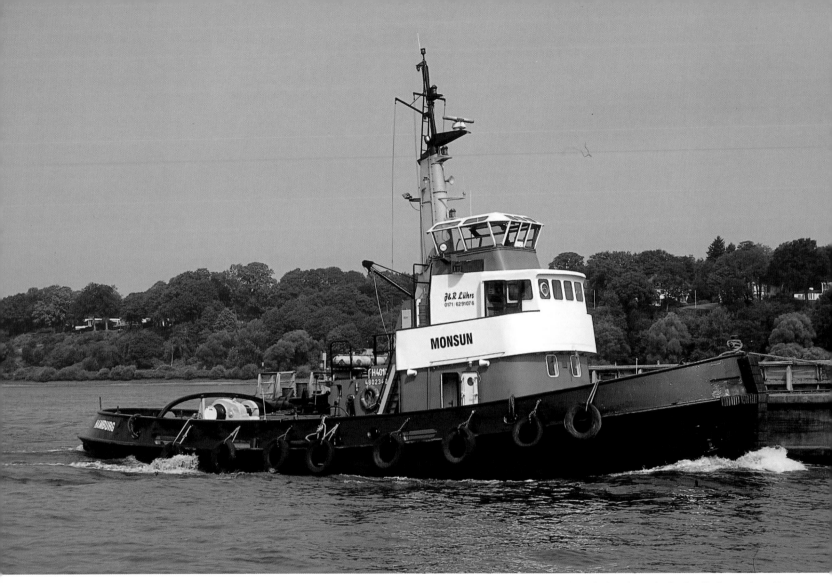

When the major tug operators in Hamburg upgrade their fleet and dispose of older vessels, the latter are quickly purchased by other owners for further use. A good example is the **Monsun** (DEU, 98gt/63). She was one of six almost identical tugs built at the Theodor Buschmann shipyard in Hamburg for Richard Borchard's Fairplay fleet. Launched on 23 April 1963, she was delivered as **Fairplay III** on 10 July of that year. Her 4-stroke 7-cylinder MAN engine of 810bhp is geared to a single screw in a Kort nozzle and gives her a bollard pull of a modest 12 tonnes. In 2003 she was sold to brothers Jonas and Robin Lührs in Hamburg where she continues to find employment although handling barges rather than ships. She is seen passing Finkenwerder on the outskirts of Hamburg on 14 August 2007.

(Dominic McCall)

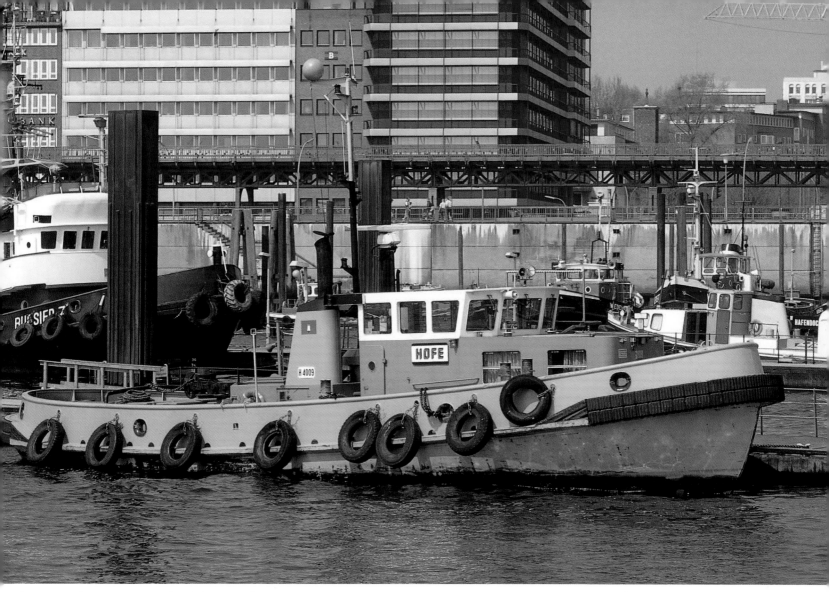

Not all tugs in Hamburg are used for shiphandling. To maintain an adequate depth of water, there is a constant dredging requirement and a fleet of tugs supports various spoil barges and other civil engineering projects. An example of such tugs is the *Hofe* dating from 1986 and built at the Theodor Buschmann shipyard in Hamburg and operated by Strom- und Hafenbau, Hamburg. She was the second tug of this name, the first having worked on the Elbe in the city between 1878 and 1978. Her distinctive colour scheme makes her more easily seen when at work in the narrow fairway of the River Elbe in the centre of Hamburg.

(*Bernard McCall*)

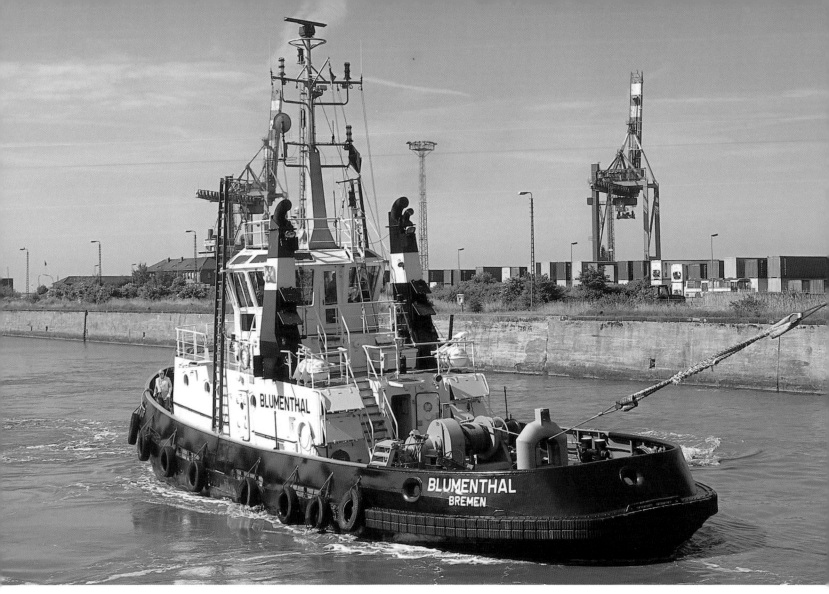

Bremerhaven has become one of the leading container ports in Europe and also has a very busy trade in vehicle exports. The **Blumenthal** (DEU, 219gt/90), noted on 2 June 2004, is part of the Unterweser Reederei (URAG) fleet which serves Bremen and other ports on the River Weser in addition to Bremerhaven. She is powered by two 4-stroke 6-cylinder Deutz engines with a total output of 2502bhp, and these drive two Voith-Schneider propellers giving a bollard pull of 27 tonnes. The tug's hull was built by Deutsche Industrie-Werke in Berlin and completion was undertaken locally at the Detlef Hegemann Rolandwerft yard in Bremen. The launch date is given as 11 April 1990 and she was delivered on 18 August.

(Dominic McCall)

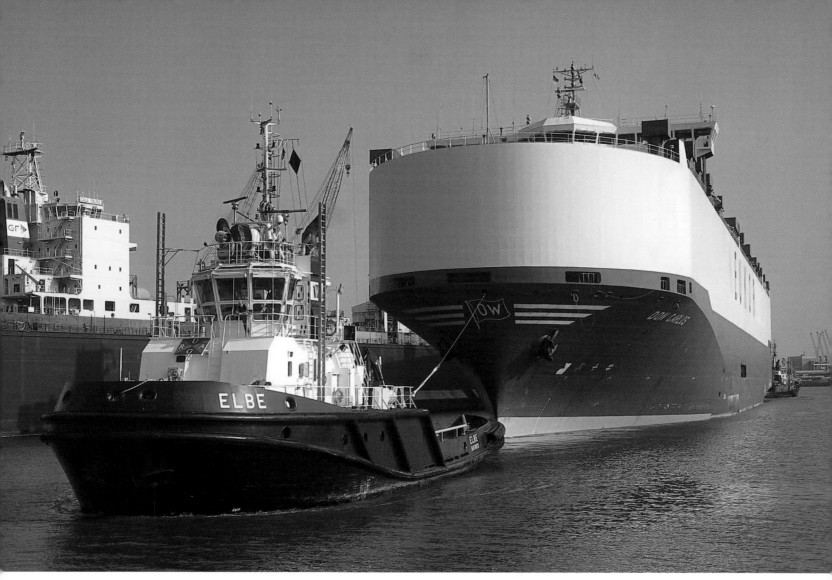

In the Introduction, we noted that the book would focus on older and less-familiar tugs. We cannot close without looking at a more modern vessel in order to complete the context. The **Elbe** (DEU, 633gt/06) is one of a pair of tugs built by Astilleros Zamacona at Santurce, near Bilbao, for URAG. She was launched on 23 June 2005 and delivered on 6 April 2006. A powerful tug, she has two 4-stroke 8-cylinder MaK engines, each of 3589bhp, which drive two Voith-Schneider propellers. At the time of delivery she and sister tug **Ems** were claimed to be the largest Voith Schneider tractor tugs in mainland Europe. As anchor handling vessels, they were designed mainly for offshore work but their 75 tonne bollard pull makes them ideal for handling the latest generation of container ships and vehicle carriers. She was engaged on such a duty when photographed at the bow of the **Don Carlos** (SWE, 56893gt/97) on 9 August 2007.

(Dominic McCall)

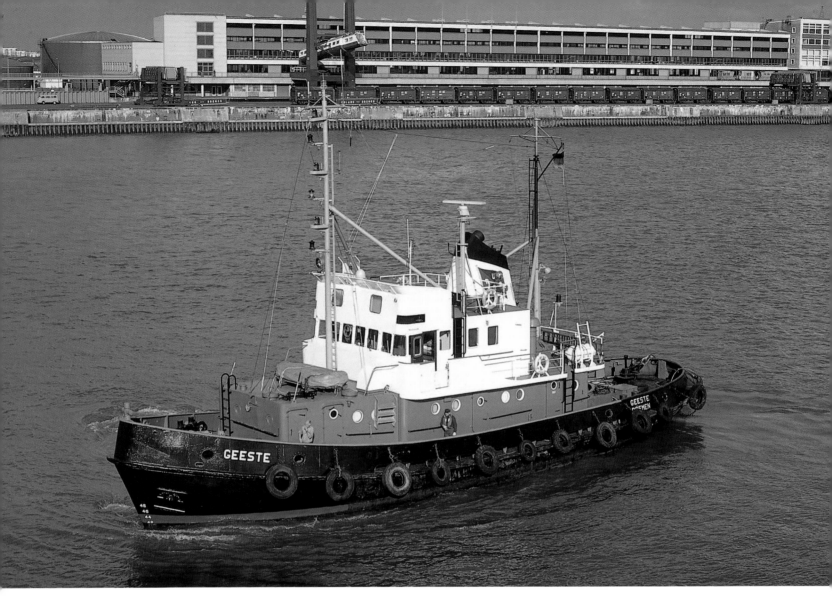

We now revert to a previous generation of tug at Bremerhaven. Noted on 2 May 1982, the **Geeste** (DEU, 190gt/66) was built at the H H Bodewes shipyard at Millingen a/d Rijn. She was launched in November 1966 and handed over to URAG the following month. In August 1992, she was acquired by Smit and renamed **Janus** but returned to German ownership in mid-December 2001 when transferred to Harms Bergung Transport & Heavy Lift, of Hamburg. In 2005, she was bought by Norwegian owners in Halden and renamed **Herbert**. Power comes from a 4-stroke 8-cylinder Deutz engine of 1320bhp which gives her a bollard pull of 15 tonnes.

(John Wiltshire)

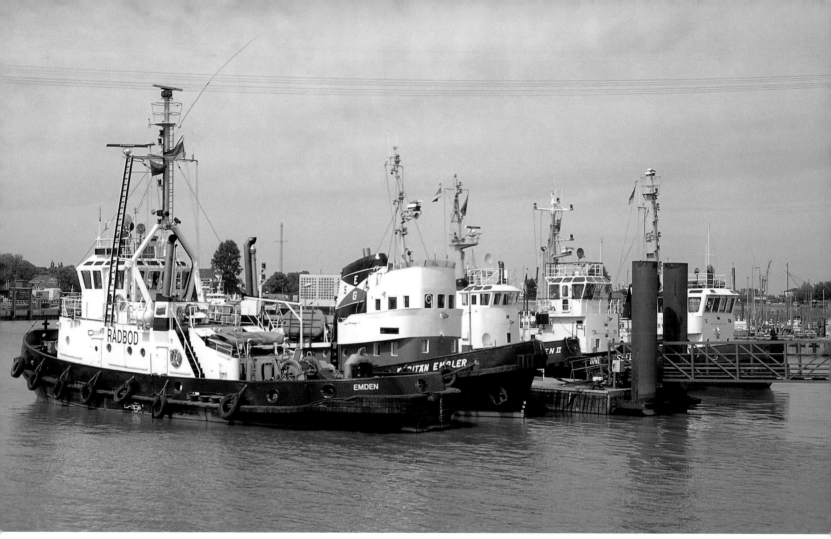

This interesting line-up of tugs awaiting work at Emden on 2 June 2002 shows vessels owned by three different companies. Nearest the camera is the **Radbod** (DEU, 213gt/77) built at the Jadewerft shipyard in Wilhelmshaven as **Vegesack** for Unterweser and handed over on 9 December 1997. She has two Deutz engines each of 900bhp which drive two Voith-Schneider propellers and provide a bollard pull of 22.5 tonnes. In 2001, she was chartered to Ems-Schlepper and renamed **Radbod**. Adjacent to her is the **Kapitän Engler** (DEU, 139gt/65) built locally by Schulte & Bruns and handed over to owners Ems-Schlepper on 16 November 1965. Her single MWM engine of 1050bhp drives a single screw in a movable Kort nozzle and provides a bollard pull of 19.6 tonnes. She was sold to Danish owners later in 2002 for use at a scrapyard in Esbjerg and was renamed **Alex Falck**. In 2004, she was sold to British owners and reverted to her original name although it was soon anglicised to **Kapitan Engler**. Reported to have been renamed **Western Rock** in early 2005, she was sold within the UK in June 2005 and became **Princeton**. Also built locally but at the Werftunion (Cassens-Werft) yard is the **Fritzen II** (DEU, 130gt/74). Owned by Wessels Offshore, her single MWM engine of 1000 bhp drives a fixed-pitch propeller in a Kort nozzle, a combination giving her a bollard pull of 18 tonnes.

(Dominic McCall)

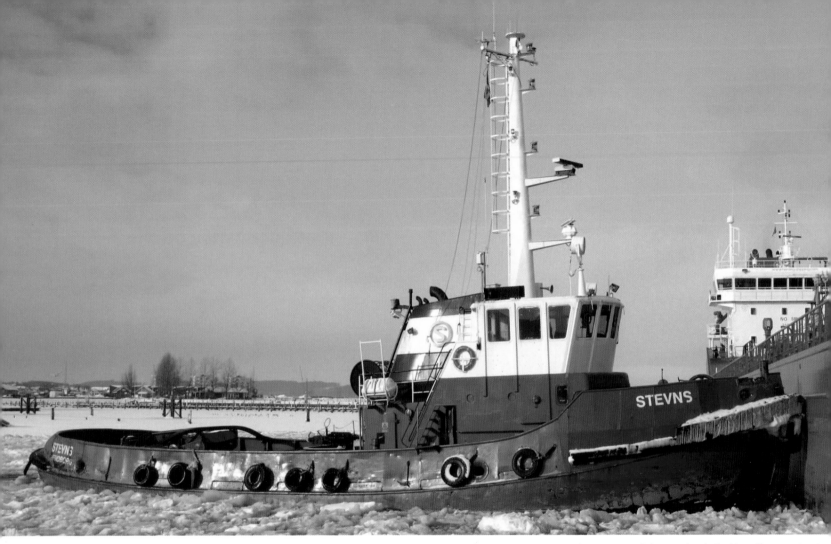

We close the book with a reminder of the work that so many tugs in northern Europe carry out during the winter months. The **Stevns** (DIS, 163gt/75), assisting the tanker **Bitten Theresa** (DIS,3356gt/98) in icy conditions at the Danish port of Struer on 4 February 2010, has a fascinating history. She was built at the Haak shipyard in Zaandam and was launched on 1 July 1975. Named **Brage**, she was delivered to Danish owners on 16 November 1975. The first significant event in her career came in March 1989 when she arrived at Karstensens shipyard in Skagen to be converted into a pusher tug. This involved fitting an articulated coupling at her bow and raising the height of her bridge. She was then sold to North East Towing Ltd, a subsidiary of the Svitzer group, and was renamed **Weswear** under the Red Ensign. Her new role was to push barges loaded with colliery waste at riverside quays on the River Tyne for disposal at sea. She returned to Svitzer ownership in Denmark in mid-1994 but the pusher modifications were not removed until February 1996. On 17 January 1996, she came into the fleet of Bugserselskabet Goliath (Goliath Towage) in Aalborg and was renamed **Goliath Fur**. Three years later her original 4-stroke 10-cylinder Alpha engine of 1450bhp was replaced by an identical second-hand engine. Since 5 February 2001, she has been owned by Stevns Charter & Towage by whom she was renamed **Stevns**.

(Bent Mikkelsen)